IMAGES
of America

BROCKTON REVISITED

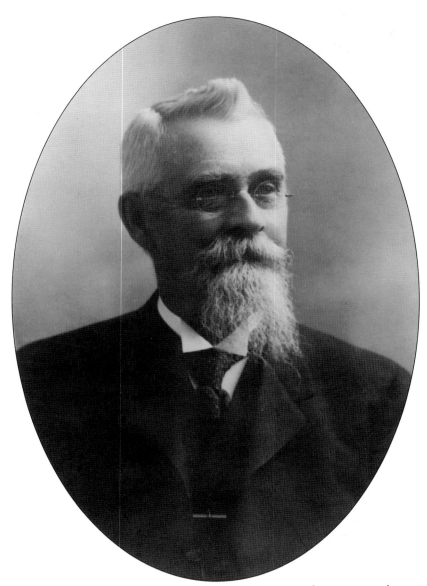

As North Bridgewater grew, it became the wish of the citizenry to have a name that would stand out and be short and quick. Many suggestions were made, such as Standish, Oriole, Winslow, Allerton, and Avon as well as others. But after much discussion, deliberation, and voting, local merchant Ira Copeland, pictured above, suggested that Brockton be considered as the town's new name, and on May 5, 1874, the citizens so voted. Copeland had heard the name when passing by train through a town so named in the Canadian province of Ontario. (Courtesy of the Brockton Public Library.)

ON THE COVER: The cover image portrays hometown hero and world heavyweight boxing champion, Rocco Francis Marchegiano, known to the world as Rocky Marciano. "The Brockton Blockbuster" is bracketed by his father, Pierino, and his mother, Pasqualena, during a Brockton homecoming celebration. (Courtesy of the Stanley A. Bauman Photograph Collection, Stonehill College.)

IMAGES
of America

BROCKTON REVISITED

James E. Benson
Foreword by Mayor Linda M. Balzotti

ARCADIA
PUBLISHING

Copyright © 2012 by James E. Benson
ISBN 978-0-7385-7668-8

Published by Arcadia Publishing
Charleston, South Carolina

Printed in the United States of America

Library of Congress Control Number: 2011933259

For all general information, please contact Arcadia Publishing:
Telephone 843-853-2070
Fax 843-853-0044
E-mail sales@arcadiapublishing.com
For customer service and orders:
Toll-Free 1-888-313-2665

Visit us on the Internet at www.arcadiapublishing.com

*This work is dedicated to the memory of a true Brockton champion,
Stanley A. Bauman, who through his photography chronicled
Brockton's many champions, great and small, for seven decades.*

CONTENTS

FOREWORD

The writer Tennessee Williams said that time is the longest distance between two places.

Such is the case between Brockton's past and future. Through the hard work of local historian James Benson, the rich and multilayered story of Brockton's history gains a new life.

There is a wealth of information about the "City of Champions" out there—whether it is recorded in books or cared for in family archives. And all of it tells a story.

The images and descriptions help remind us where our city has come from and provide an understanding of where it is headed.

Going through all this information and sorting it into an easy-to-read format is no small task. And I appreciate the time and effort it has taken James Benson to delve into Brockton's past. As a result of this, Brocktonians past, present, and future will now have a wonderful resource about the community they love.

Best regards,

Linda M. Balzotti
Mayor

ACKNOWLEDGMENTS

The undertaking of any project, such as this, takes the involvement and dedication of many people and institutions. This volume would not have be possible without the help of the following people and institutions: the Brockton Historical Society and its board of trustees, Lucia Shannon and the Brockton Public Library, A. Laverne Ekberg, Paul A. Olson, Joanne Shotwell, Harold A. Swanson, the Tosches and Zibelli families, First Evangelical Lutheran Church, Dr. Robert Haglund, Donald and Christine Newman, Lawrence Siskind, Lloyd F. Thompson, and Amy Korim.

Many of the images in this volume are from the Stanley A. Bauman Photograph Collection at Stonehill College in Easton, Massachusetts, and I am grateful to be able to include them in this volume.

A large debt of gratitude is owed to Nicole Tourangeau-Caspar, the director of Archives and Historical Collections at Stonehill College, and her assistants for their hours of dedication to the Bauman Collection and in assisting me in choosing and preparing images for this volume.

A special word of appreciation is due to Brockton mayor Linda M. Balzotti for the writing of the foreword for this volume and for her support of preserving and promoting the city's history. Mayor Balzotti is, herself, a historical figure in Brockton's history, being the first woman elected to that office. In addition, a special word of thanks goes to the entire staff of the mayor's office for their cooperation and support when needed.

A special thank you goes to Lissie Cain and the staff of Arcadia Publishing for making this, my fifth venture with Arcadia, an enjoyable experience, even in spite of technical delays caused by tropical storm Irene. Their professionalism is above reproach and greatly appreciated.

For any omissions and errors in the spelling of names or identifications of individuals and locations, apologies are given; however, the text reflects original information as it appears on or with the original photographic image.

Finally, no project of any magnitude can be accomplished without the support of family and friends, and to that end, I thank my parents, S. Erick and Leah A. Benson; my sister and her husband, Cheryl and Philip Packard; my niece and her husband, Corinne E. Packard, PhD, and M. Scott Bradley, PhD; my nephew Christopher J. Packard; and Peter L. Borsari and family for being there to listen to me when things were not always going well. Thank you to all.

INTRODUCTION

The city of Brockton has long been called the City of Champions, a moniker well deserved but occasionally overdirected in its focus on sports and the great legacy the city has in the arena. *Brockton Revisited* attempts to take the reader on a journey into the past, highlighting the other champions that made Brockton the city it is. Champions from every walk of life contributed to the building of the city and continue to do so.

This volume does not attempt to be a definitive history of Brockton but uses a large array of vintage photographs to give the reader the sense of a great city with a great history. In *Brockton Revisited*, the eyes of the reader will be opened to many images not seen by the general public since they were taken more than a century ago.

Readers will see many magnificent buildings that are no more—lost gems of architecture. Many were lost to the ravages of a national climate of urban renewal in the 1960s. Fortunately, attitudes change and have changed toward historic preservation, and with this, it is hoped that Brockton's remaining architectural and historical structures will remain in place for the edification of future generations.

For many who peruse these pages, these images will stir feelings of nostalgia—and rightly so—but it is important not to dwell on what was but to look at what can be built upon this storied past.

One

CHAMPIONS OF INDUSTRY AND COMMERCE

As much as it was a manufacturing center of shoes, Brockton also had many retail outlets for footwear, including Nate Siskind's at 72 Legion Parkway, which specialized in shoes for both men and women. Rocky Marciano was a regular patron of Siskind's, and Nate's son Lawrence is a prominent attorney and past president of the Brockton Historical Society. (Courtesy of the Stanley A. Bauman Photograph Collection, Stonehill College.)

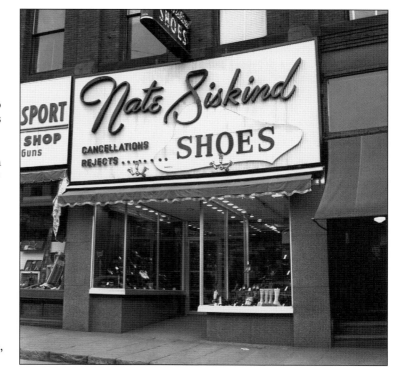

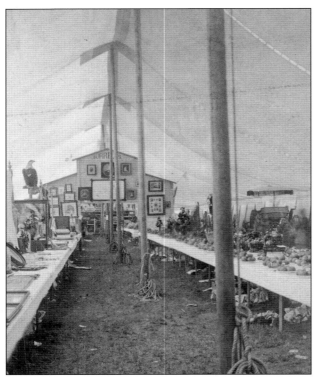

On July 9, 1874, the Brockton Agricultural Society was officially organized under the laws of Massachusetts with the purpose of "encouraging and promoting the material prosperity of this community in every form of productive industry." The society constructed a trotting track on a 30-acre parcel at Belmont and Torrey Streets during the summer and held its first exhibition in October 1874. In those first years, the exhibitions were set up in massive tents as large as 205 feet by 95 feet. These two images portray such tents, with displays of produce and farm products as well as artwork and photography. It is possible that these two images are from the first exhibition of 1874. (Both, courtesy of the Brockton Historical Society.)

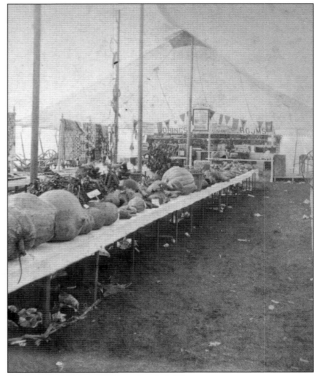

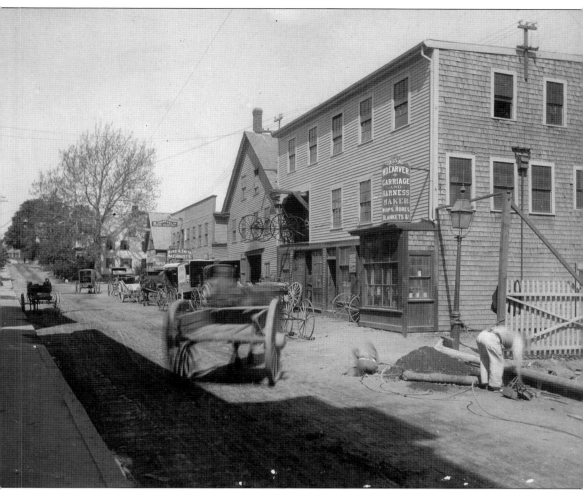

Brockton's High Street was a center of commerce as well as history. The first building on the right housed the carriage works of William O. Carver and was established in 1876. By the end of the first decade of the 20th century, Carver was also advertising himself as an automobile painter, thereby keeping up with the times. Next up the street were the machine shop of Burr and Smith, the shops of Chase & Co. painters, and Lawrence's paint and wallpaper store. In the rear of the photograph is the home of Edward Bennett and the famed Liberty Tree, both important stops on the Underground Railroad and important meeting sites of local abolitionists. (Courtesy of the Brockton Public Library.)

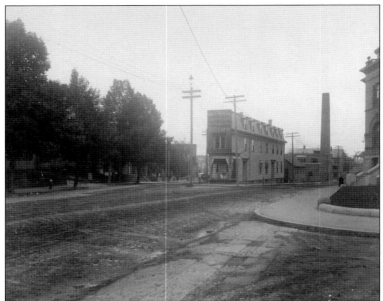

Before New York City could boast of its flatiron building, Brockton had its own at the confluence of School and Lincoln Streets. This building was home to the paint shop of Lucius Richmond prior to the company's move to Main Street. Immediately behind the building was the Edison Illuminating Company's plant, and on the right can be seen a corner of city hall. (Courtesy of the Brockton Public Library.)

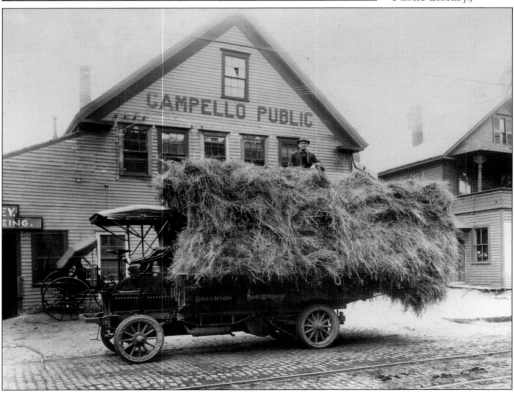

The driver of this Brockton Heel Company truck poses on top of a load of hay in front of the Campello Public Market at 31 Perkins Avenue. Brockton Heel was located on Terminal Place in Campello. Note the vertical steering column on the truck and the horizontal steering wheel, similar to a hand brake on a railroad boxcar. (Courtesy of the Brockton Public Library.)

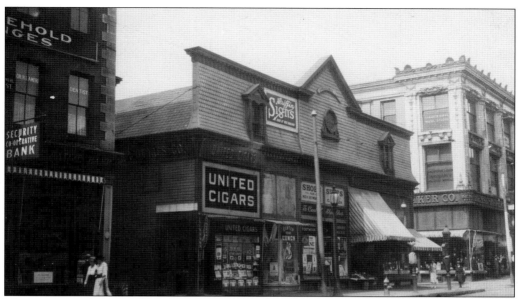

The block shown above, built in 1890 and home to H.W. Robinson Carpet store, United Cigars, and the Central Shoe Shop, was located about where the entrance to Legion Parkway is today. The structure to the right is the Besse-Baker Building, now the location of the Neighborhood Health Center. The image below is a view of Centre Street looking from Montello Street to Main Street. The structures on the left are where the W.B. Mason buildings are today. The large structure on the left foreground is the backside of Central Methodist Episcopal Church, the next building is the Millinery shop of Lena Wade-Whitman, and the one following houses the lamp shop of Charles W. Goss. (Above, courtesy of Christine and Donald Newman; below, courtesy of the Brockton Public Library.)

This view is looking down the north side of Centre Street from Main Street. On the left-hand side of the photograph, the building with the white awnings, the Mason Block, is occupied by the Great China and Pacific Tea Company and the Brockton Book Bindery. The next building houses the Gospel of Joy Mission and a restaurant; the following structure is home to Edward Brophy's tailor and clothes cleaning shop; the succeeding building is occupied by the Brockton Pants Co. The last building partially in view is the Gardner Block. (Courtesy of the Brockton Public Library.)

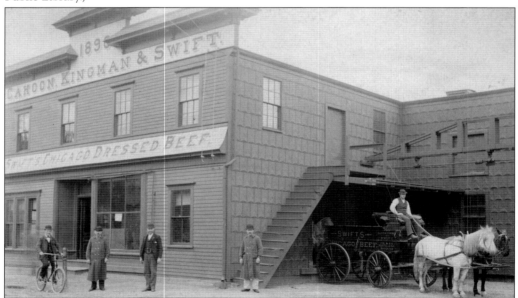

Gustavus Swift, a native of Cape Cod and founder of the meat company bearing his name today, was the first person to effectively transport Midwestern meat to Eastern markets via refrigerated railcars. By 1885, the Grand Trunk Railroad was hauling nearly 300 million pounds of beef eastward annually. The local purveyor of Swift's products was the firm of Cahoon, Kingman & Swift at 240 Montello Street. (Courtesy of the Brockton Public Library.)

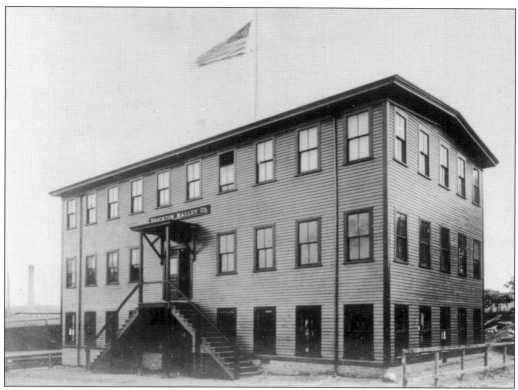

With the large presence of shoe manufacturers in the city, Brockton spawned many ancillary industries, making it a hotbed of entrepreneurship. Among those who established themselves in that way was George B. Goddard, a native of Quebec, a whaler out of New Bedford at age 14, a two-time shipwreck survivor, and a veteran of great Civil War battles at Fredericksburg, Antietam, Chancellorsville, Gettysburg, and more. Coming to Brockton in 1873, Goddard worked for the Stacy, Adams Company and patented his first rawhide mallet in 1878. In 1886, he established the Brockton Mallet Company, shown above, on Field Street, located across from his beautiful home, shown below. His home is still standing on Montello Street. Goddard died in 1905, and his son George A. Goddard assumed ownership of the company. Goddard's sales literature combined product information along with quotes on work, love, and patriotism. (Both, author's collection.)

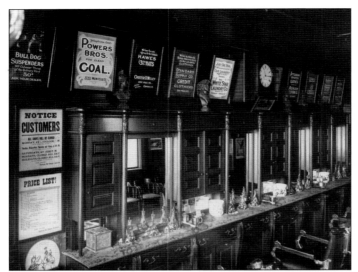

In the 1924 city directory, there were 90 barbers listed in the city, among them Pedro "Pete" Lange, who operated a multi-chair shop. Pictured here at 230 Main Street, Lange's shop was elegant compared to most, with large mirrors, carved cabinetry, and a marble-topped counter. The signs above the counter advertise local businesses, and the price list sign has multiple options. Haircuts were 25¢, and a shave was 10¢. (Courtesy of the Brockton Public Library.)

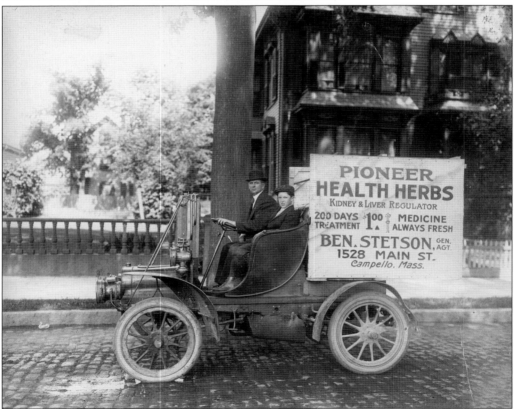

In this 1916 image, healthful remedies are nothing new. Benjamin Stetson of Campello, shown at the wheel, was a streetcar motorman who supplemented his income by being a purveyor of some sort of early-20th-century snake oil, known as Pioneer Health Herbs. A total of 200 days of treatment for only a dollar . . . that would make most insurance plans happy today. (Courtesy of the Brockton Public Library.)

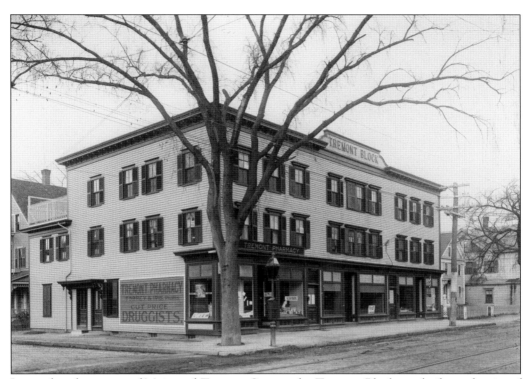

Located at the corner of Main and Tremont Streets, the Tremont Block was built on the site of Drake's Tavern. In this photograph, the block is home to the Tremont Pharmacy and an unidentified barbershop. Above street level were rented rooms. Today, this is a vacant lot. (Courtesy of the Brockton Public Library.)

Locally owned Dunnington's Apothecary was one of the earliest multilocation pharmacies in the area to serve both individuals and local physicians and hospitals. Operated by George and Herbert Dunnington, this company boasted four Brockton locations and a Taunton location in the early 1950s. Like its other homegrown counterparts, this household name would eventually give way to the national corporate giants. (Courtesy of the Brockton Historical Society.)

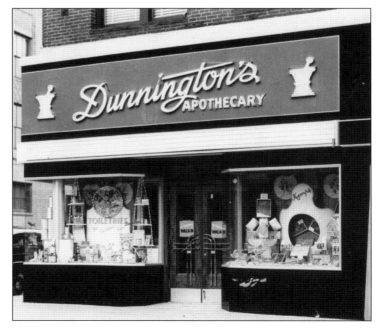

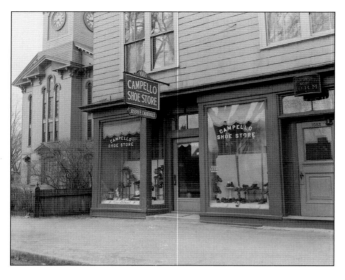

Located next to the historic South Congregational Church, the Campello Shoe Store, owned by Joseph F. Carriulolo, provided footwear for several generations of Brocktonians. The upper floor of this building was the home to the International Order of Redmen. The facade of the store has changed since this 1948 photograph was taken, and today, the building is home to New England Brass Refinishing, owned by Ron Bethoney. (Courtesy of the Stanley A. Bauman Photograph Collection, Stonehill College.)

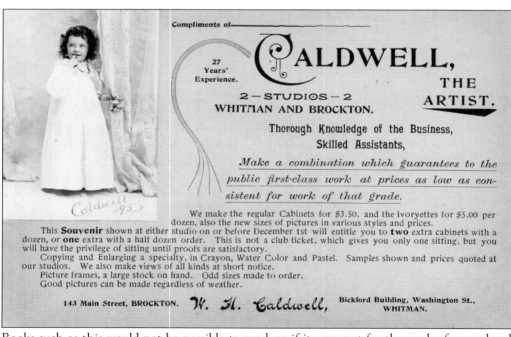

Books such as this would not be possible to produce if it were not for the work of many local photographers and the great work they produced in an age of innovation and a new technology. Warren H. Caldwell, whose advertising card is pictured here, was one such photographic artist in Brockton. Work by studios, such as Caldwell's, was affordable to most, and the immigrants of the city would have photographs of children and themselves taken to send back to the "old country." (Author's collection.)

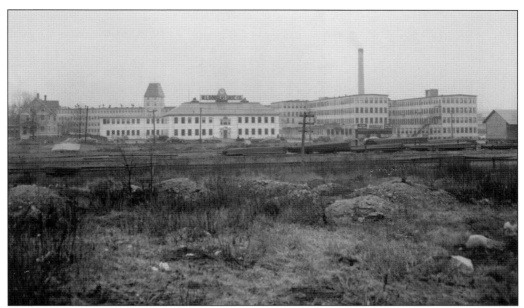

In 1950, the W.L. Douglas Shoe Company, shown above, closed its doors after 74 years in business. Founder William Lewis Douglas did everything on a large scale. For example, this was the largest shoe factory under one roof in the world, and he was the largest producer of men's shoes in the world. A master at self-promotion, he launched the first six-masted, steel schooner ever built, aptly named the *William L. Douglas*, in 1903. Pictured below is a group of Douglas shoe workers from the early years of the 20th century. Note the age variation from very young to old; for most, this was a lifelong career. (Above, courtesy of the Stanley A. Bauman Photograph Collection, Stonehill College; below, author's collection.)

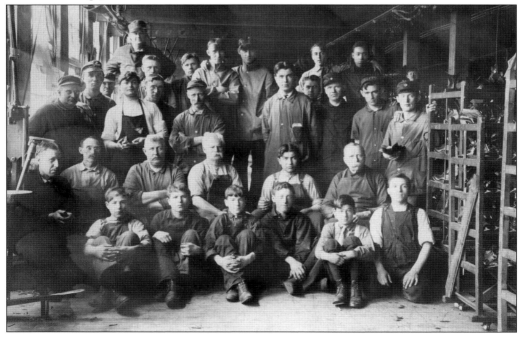

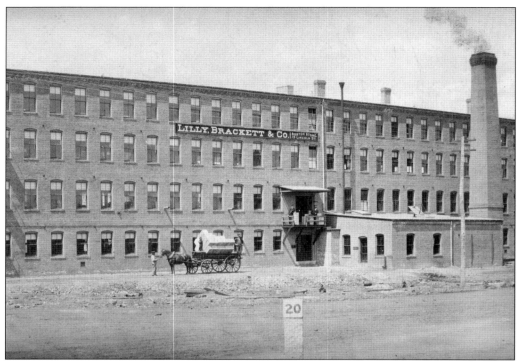

In 1880, Lilly, Brackett & Company of Boston built Brockton's first brick shoe factory, located along Montello Street and Railroad Avenue. In 1908, the George M. Knight Company, a manufacturer of shoe equipment, purchased the building. The building was also home to Stall & Dean, manufacturers of sports equipment and uniforms. This view of the factory is from the railroad track side. (Courtesy of the Brockton Historical Society.)

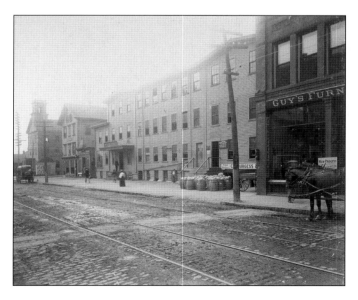

Centre Street was the second main street of the city, with a variety of mixed business uses located within a short distance. On the right of this image is Guy's Furniture Company, and to the left is the O.O. Patten Company, manufacturers of blackings and cements, while in the same building are located the Isaac Fish Company, manufacturers of box toes; the Chase Lasting Machine Company; and, most unlikely of all within a manufacturing district, the Burgess Produce Company. (Courtesy of the Brockton Public Library.)

On September 19, 1881, Pres. James A. Garfield died after having been shot on July 2. Here, the H.W. Robinson Company's Cash Store is draped in black crepe with a picture of the martyred president in the window. Henry Robinson's son James, who grew up in the family business, established the J.W. Robinson Dry Goods Company in California and grew it into what is today, through many mergers and acquisitions, Macy's department store. (Courtesy of the Brockton Public Library.)

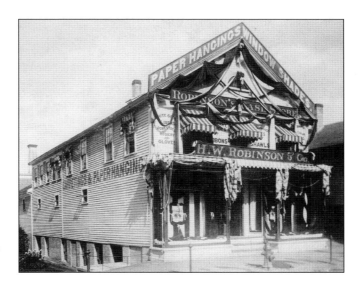

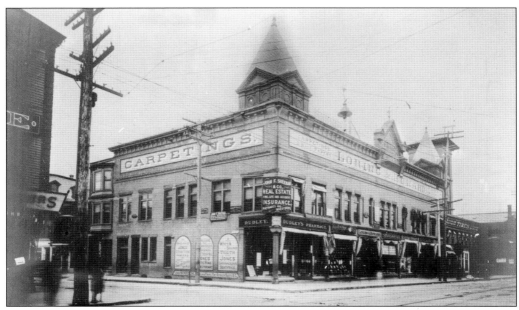

The Opera House Block stood at the southeast corner of Main and East Elm Streets and was the location of Loring and Howard, a well-known purveyor of carpeting, wallpaper, and draperies. The low building adjacent to the opera house was the original home of the *Brockton Times* newspaper. The sign on the end wall of the building advertises Jones's saponaceous dentifrice, which is more commonly known as toothpaste. (Author's collection.)

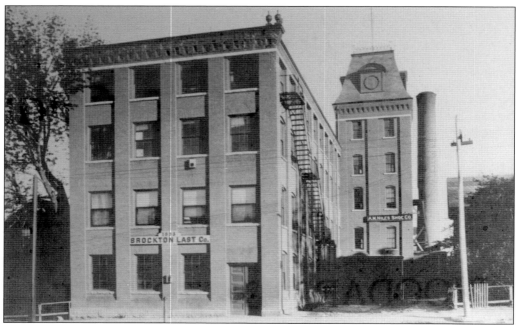

This castle-like factory on Court Street was the home to the Brockton Last Company, just one of the many shoe-related industries located within the city. This company manufactured lasts, the form upon which a shoe is made, as well as shoe patterns for high-end shoes and boots. The Brockton Last Company sold to shoe manufacturers worldwide and had offices in Boston. (Author's collection.)

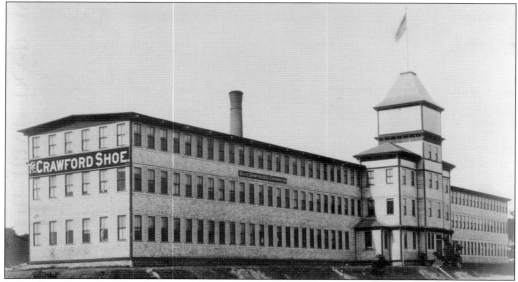

After founding Bouve, Crawford & Co. in 1887, Harvey Crawford, along with George and Lander Bouve, built this factory on Bellevue Avenue. Crawford had been associated with Frank Hill, a traveling salesman, who is often credited with the idea of manufacturers selling their own shoes in company stores. Bouve, Crawford & Co. opened stores in Boston, New York City, Brooklyn, Philadelphia, and other major East Coast cities. (Author's collection.)

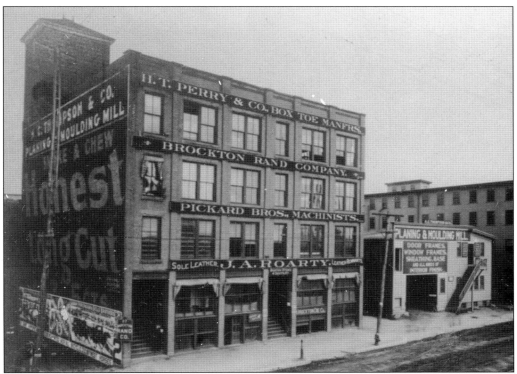

The A.C. Thompson Company on Railroad Avenue was one of the region's largest manufacturers of door and window frames, fancy millwork, and trim. Beside the planning and molding mill stood the four-story structure that was home to several shoe-related industries; the Pickard Brothers machine shop; the Brockton Rand Company, manufacturers of heels, rands, and welts; a box toe manufacturer, H.T. Perry; and the leather firm of J.A. Roarty. (Author's collection.)

Located where the Brockton Trial Court stands today at 183 Main Street, the Plymouth Country Safe Deposit and Trust Building was an imposing structure and also home to the bicycle and sports shop of Horace A. Keith, the Plymouth Rock Pants Co., and Christie's hairdressing parlors. (Courtesy of the Brockton Public Library.)

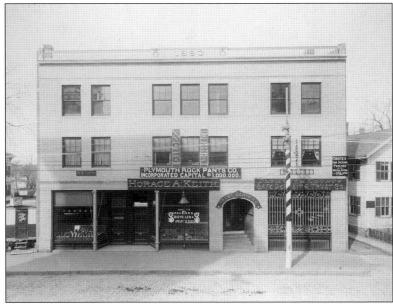

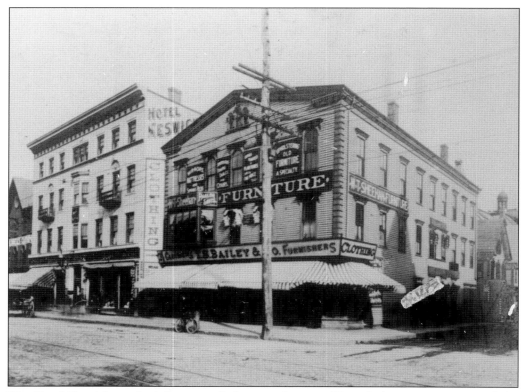

The Hotel Keswick on the left eventually became the site of Fraser's department store, and the wood-frame building on the corner, housing the men's clothier T.S. Bailey and the furniture company of W.T. Sheehan, is where Romm's Jewelry store was prior to its relocation to Belmont Street. The bell cupola of city hall can be seen in the background. (Author's collection.)

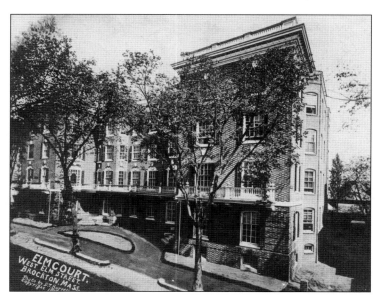

This 1906 image portrays downtown's luxurious Elmcourt Hotel, built in 1903, on West Elm Street. Expanded to more than double its size, the hotel was renamed the Bryant Hotel. John F. Kennedy made frequent campaign stops at the Bryant. In the 1970s, the Yannone family purchased the property and, in the late 1990s, renamed it the Elmcourt. (Author's collection.)

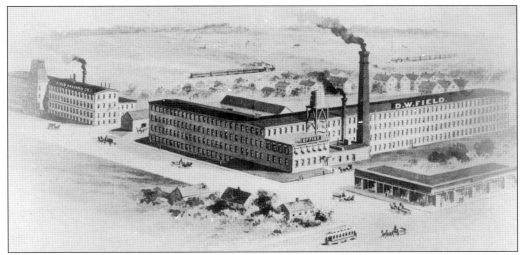

This engraving depicts the shoe factory of Daniel Waldo Field, located at the corner of North Main Street and Emerson Avenue in the Montello section of the city. The one-story, detached building in front was a retail shoe store operated by Field and is the present-day location of Rice's Market. The shoe factory also housed another Field enterprise, the Montello Heel Company, one of Brockton's last shoe-related industries, operated today by the Pearson family. (Author's collection.)

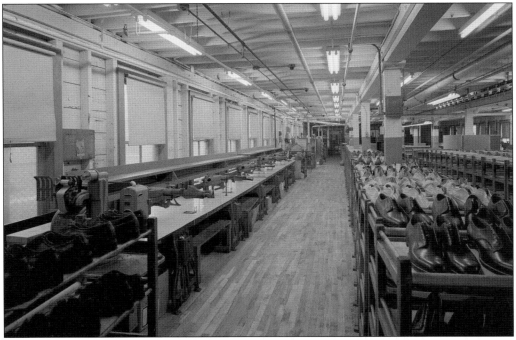

One of Brockton's best-known names in shoes was Stacy, Adams & Company. Established in 1875, this firm manufactured a high-quality men's shoe. This image depicts the interior of the factory in 1964 as the shoe industry in Brockton was in its waning years. The Stacy, Adams name lives on through the Weyco Group in Wisconsin, which retails vintage shoe designs under the name Brockton Originals. (Courtesy of the Stanley A. Bauman Photograph Collection, Stonehill College.)

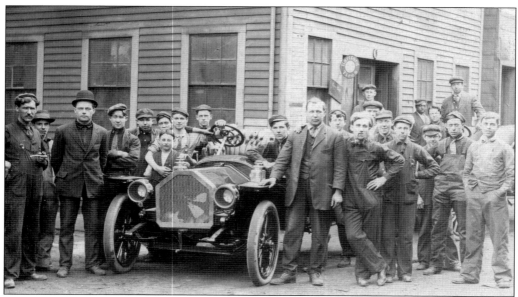

While not on the scale of Detroit, automobile manufacturing did take place in Brockton. Among the vehicles built in Brockton was the Pickard, built by the Pickard brothers, Benjamin, Emil, and Alfred. Their Foundry Street factory, pictured above, produced a high-quality brass-era vehicle, as shown below. Like so many other small, local automobile manufacturers, the Pickard nameplate was short lived. Very few of the vehicles remain in existence today. Other manufactures of motor vehicles in Brockton were the American Motor Car Company, makers of the Marsh, later manufacturers of Marsh and Marsh-Metz motorcycles; the Cameron Motor Car Company; and the Roader Car Company. As automobile manufacturers, all of these companies disappeared within five years, and only Marsh existed once it changed to motorcycle manufacturing. (Above, courtesy of Paul A. Olson; below, courtesy of the Brockton Public Library.)

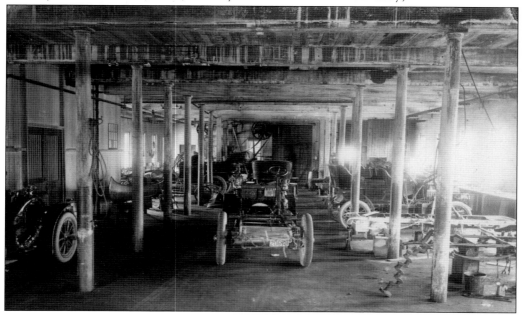

MANUFACTURERS

COMBINING

SIMPLICITY, DURABILITY and RELIABILITY

Stylishness in Appearance and Symmetry in Design

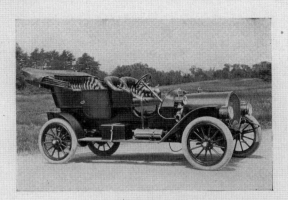

We invite the strictest investigation
and challenge comparison of value.
EASY TO OPERATE and with the least
expense. GAURANTEE goes
with every car

PICKARD BROTHERS

MANUFACTURERS

Brockton - - **Massachusetts**

Though small in product and capacity, companies, such as Pickard, did not spare funds when it came to advertising, and their advertisements were in line with the big names of the industry. However, these advertisements did lack in proofreading, as indicated by the word "gaurantee." Other companies took advantage of the growing popularity of automobiles and opened dealerships and repair facilities. (Author's collection.)

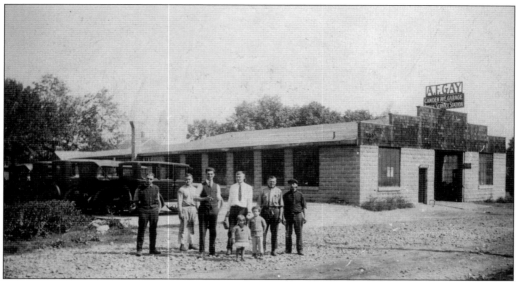

Alfred F. Gay owned the Camden Avenue Garage, pictured above with an unidentified group, and was a dealer of Dodge and Veile automobiles. Gay issued Camden Avenue Garage's stock certificate No. 1 for 35 shares, at $100 per share, to Frank E. Copeland on January 1, 1925. The Veile was manufactured from 1908 to 1928 and was founded by Willard Veile, grandson of John Deere. In its first year of production, the company sold 1,000 vehicles. (Both, courtesy of Nancy Hatchfield.)

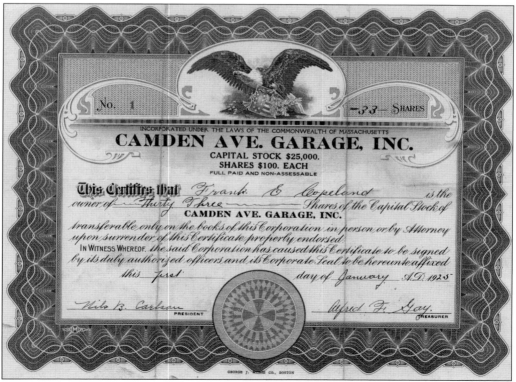

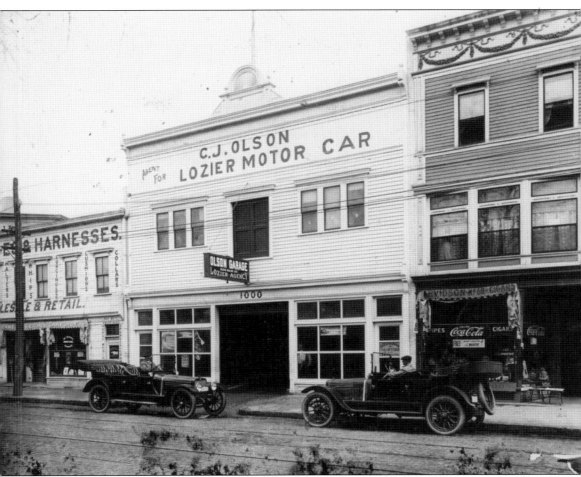

The new and the old meet at 1000 Main Street in Campello. The carriage and harness shop of James Keith on the left is dominated by the Lozier Motor Car Company of agent Charles J. Olson. Auto dealers of the time did not have the expansive outdoor display areas or the inventory that the dealers of today offer. The Lozier was manufactured from 1900 to 1915 and was at one time the most expensive automobile manufactured in the United States. A 1910 model Lozier cost between $4,000 and $8,000, while a Cadillac was $1,600 and a Packard was $3,200. In 1915, after a potential merger with Ford fell through, the company went out of existence. To the right of the photograph is the cigar-manufacturing facility of John W. Arvidson. Arvidson manufactured high-grade cigars under the names of Captain Ericsson, Plymouth 5 Cent, and 7-50-6 Ten Cent. (Courtesy of the Brockton Public Library.)

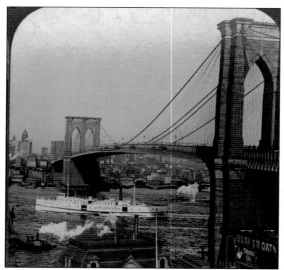

The Old Colony railroad and the Fall River Line steamboat company linked Brockton to New York City and served as a route by which immigrants could come from Ellis Island to the shoe factories of Brockton. This vital transportation link aided the growth of the city as a manufacturing center. Shown here passing under the Brooklyn Bridge is the elegant Fall River Line steamer the *City of Brockton*, built in 1886. (Author's collection.)

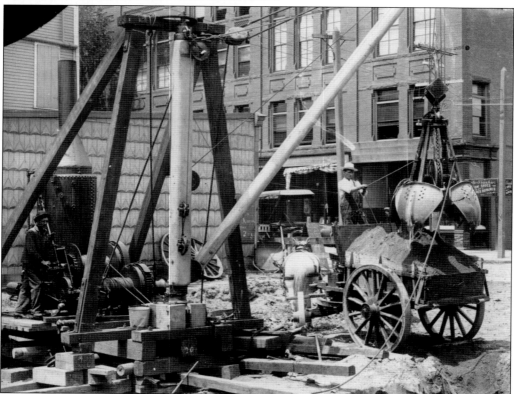

Better than shovels is perhaps all that can be said of this image of construction at the corner of Montello and Centre Streets by the Powers Brothers. Imagine the time and labor to set up a steam hoist to dig a hole and the time for the horse and cart to remove its load and return for another. The Powers brothers, James and William, were the premier contractors of their day in the city, and James would serve as superintendent of streets for the city. (Courtesy of the Brockton Public Library.)

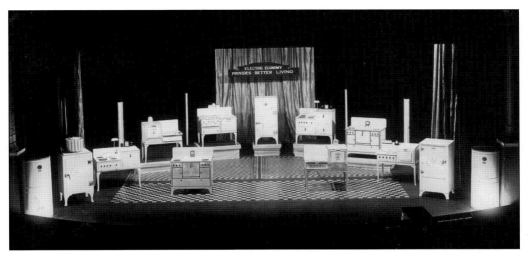

Imagine being afraid of electrical appliances—that was the feeling when electric-powered appliances first came to market a couple of generations ago. These two images of a display by the Brockton Edison Company (above) and a Brockton Fair display by the Pearson Appliance Company (below) showcase futuristic-appearing, elegant appliances that were designed more for looks than functionality. In many of the stoves and refrigerators can be seen design elements lingering from gas ranges and wooden iceboxes. Brockton Edison held special seminars on cooking with electricity to allay fears of ruining food or, worse, being injured by the appliance. (Both, courtesy of the Brockton Historical Society.)

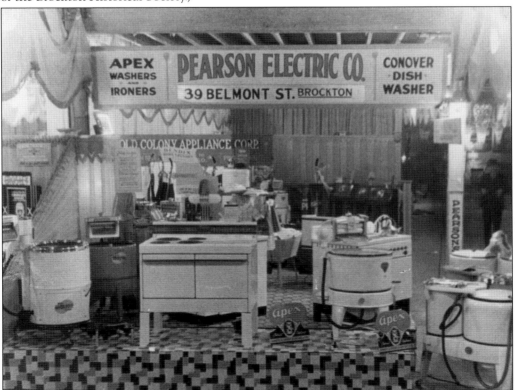

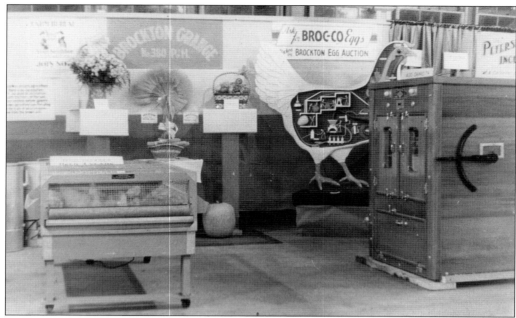

In the years following the Great Depression, when companies and families began to recover interest in one's home and property began to take on a new look, the average person began to invest more and more in the upkeep of property. It was also a time of new innovations for both home and business. These two photographs from the 1938 Brockton Home Show indicate such progress. The above image shows a display by the Brockton Grange, with a Petersen Incubator next to it in the Brockton Egg Exchange booth. The image below depicts the latest available products in home heating at a time when coal was still a major source of heat in many homes. (Both, courtesy of the Brockton Public Library.)

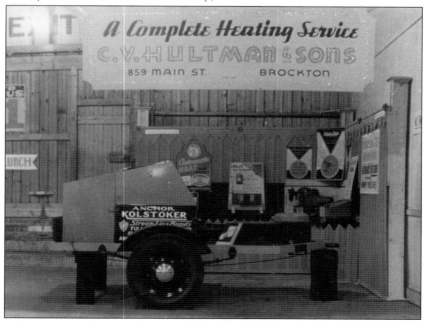

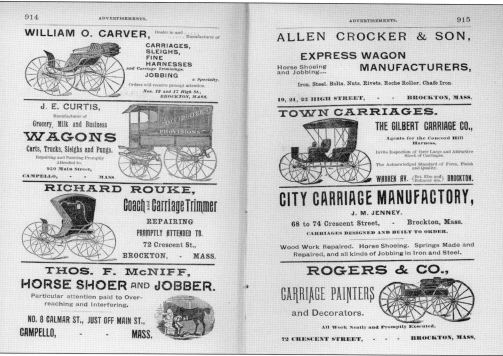

City directories provide valuable historical insight into the times. The above image is from the 1896–1897 directory and shows a small portion of the carriage and wagon trade that was going on in Brockton at the time. All types of horse-drawn vehicles were available and needed, as were the many associated services, such as blacksmiths, painters, and harness-makers. The image below shows just a small portion of the grocers, meat markets, and the like that were in the city at the time. Each of these markets had its own specialty, from cuts of meat to ethnic selections. (Author's collection.)

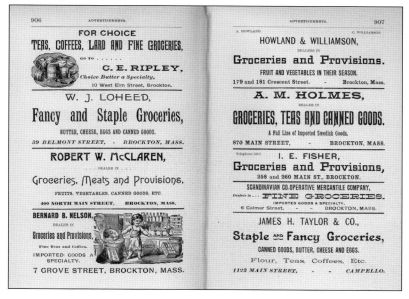

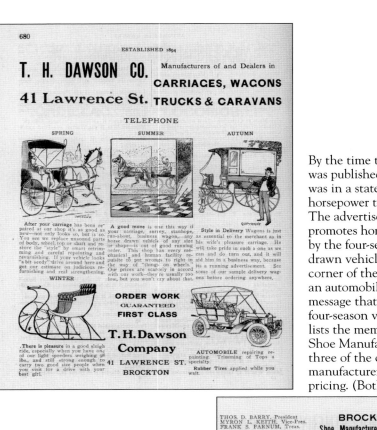

By the time the 1909 city directory was published, the country and city was in a state of transition from horsepower to mechanical power. The advertisement at left still heavily promotes horse travel, as indicated by the four-season selection of horse-drawn vehicles, while only one corner of the advertisement shows an automobile, perhaps a subliminal message that the motorcar was a four-season vehicle. The image below lists the members of the Brockton Shoe Manufacturer's Association and three of the city's prominent shoe manufacturers along with period pricing. (Both, author's collection.)

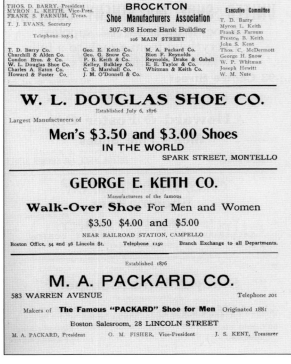

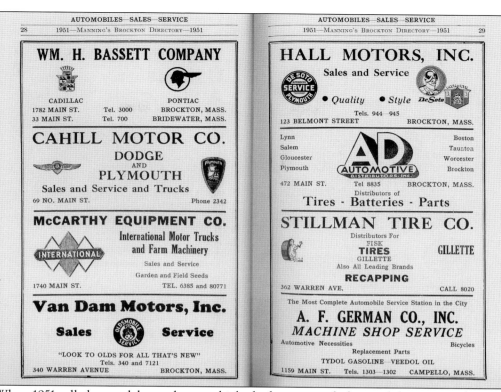

When 1951 rolled around, horse-drawn vehicles had pretty much departed the scene and were a nostalgic remembrance. The page shown above advertises some of Brockton's premier automobile dealerships and the nameplates they sold. Also advertised are companies that supplied the needed accessories from batteries to parts to gasoline. The image below shows a variety of companies, including three of the city's well-known jewelers. Having been founded by Alexander Romm in 1900, Romm's continues its existence in Brockton after more than a century in business. (Both, author's collection.)

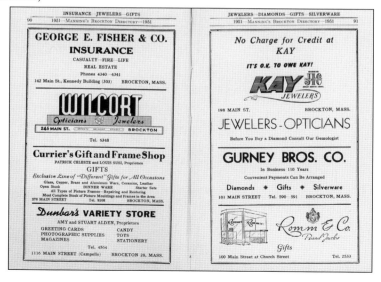

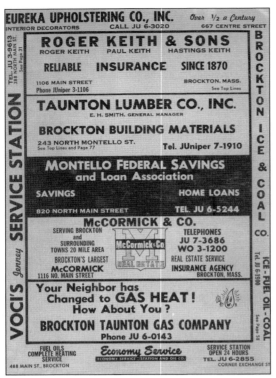

The 1961 cover of the directory shown at left advertises a number of household names at the time. Roger Keith & Sons Insurance continues to do business in the city—over 140 years—and may be the city's oldest continually operating business. Note the advertisement near the bottom encouraging people to switch to gas heat, the new energy that was coming into vogue at the time. Shown below from the 1963 directory is a page stating that the agricultural needs of the region were supplies by F.H. Sargent & Sons. The page also informs shoppers that Thompson Florist and Garden Center, which had its beginnings on Tribou Street and in the Vasa Block on Main Street, had expanded to a new location on Plain Street and sold some of the preeminent brands of power lawn equipment available. (Both, author's collection.)

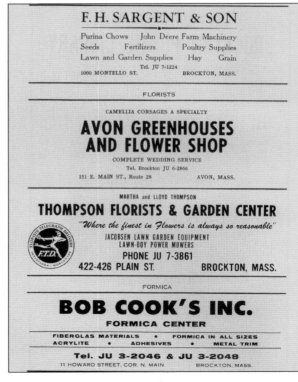

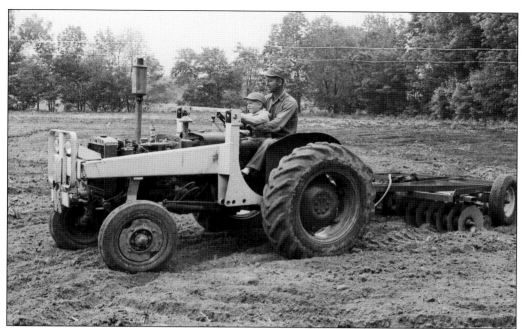

Though a manufacturing center of eastern Massachusetts, Brockton retained many of its agricultural roots for many years through farms of all types, including several dairy herds. Though the dairy herds are gone, small agricultural enterprises, such as the Packard Farms at the corner of Pearl and Torrey Streets, still provide for the green thumb gardeners of the area. This October 14, 1964, photograph shows Fred Packard preparing one of his fields for winter. (Courtesy of the Stanley A. Bauman Photograph Collection, Stonehill College.)

Brockton boasted many restaurants over the years, including the Brockton Café at 426 Main Street. Advertising over its door "famous pizzas," Brockton Café is pictured in 1966. Whether a Greek salad at Christo's, a bar pizza at the Cape Cod Café, a prime rib at the Capeway Manor, or Italian food at the Italian Kitchen or George's Café Brockton, restaurateurs offered something for every palate. (Courtesy of the Stanley A. Bauman Photograph Collection, Stonehill College.)

Located at 75 Plain Street, the Brockton Lumber Company was one of the region's most modern building material firms when the above 1959 photograph was taken. Today, no independent lumber and building material retailers remain in the city. Over the years, Brockton has seen many establishments come and go as the industry has changed and as the "do-it-yourself" market has grown into a mega industry. Below is an interior shot of the showroom at Brockton Lumber Company displaying the latest in power tools and building supplies. The showroom was bright, clean, and well merchandised. In 1951, Brockton had six full-line lumberyards as well as 20 hardware stores and an equal number of paint stores. (Both, courtesy of the Stanley A. Bauman Photograph Collection, Stonehill College.)

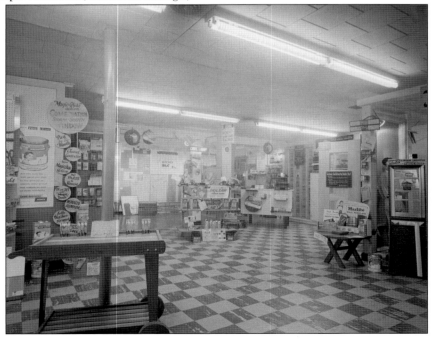

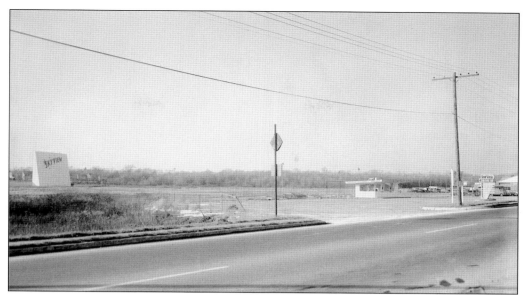

The Brockton Airport, owned by James Keith, was located at the south end of Main Street by the West Bridgewater line. This 51-acre airport closed in the mid-1950s, and its space was converted to other uses, including the construction of one of the regions earliest drive-in movie theaters, SkyView, pictured in the above photograph. Below, the Quonset-style hanger to the right became the home of Whittemore's Auto Body shop, while the office building became home to SkyView Motors, dealers in automobiles and boats. Bob and Ken Fisher operated a restaurant on the site for many years before moving farther down Route 28, and a House of Pancakes also occupied the SkyView Motors Building before the entire tract was cleared and developed into a site of various strip malls and K-Mart. The drive-in site is today the location of a senior living development, and no remnants of the drive-in or airport exist. (Both, courtesy of the Stanley A. Bauman Photograph Collection, Stonehill College.)

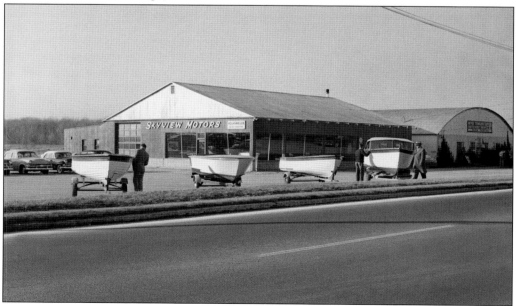

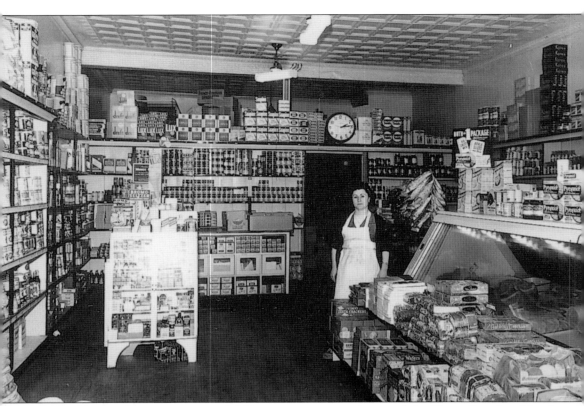

Neighborhood grocery stores and delicatessens were a mainstay of city life until replaced by the larger convenience stores of today. Every neighborhood had its own store; many of them were so called "parlor stores" because they were oftentimes in a front room of a residential home. One such neighborhood store that was a landmark in the Campello neighborhood was the Brockton South End Market, located at 1439 Main Street at the corner of Brookside Avenue and owned by Pasquale and Christine Tosches. This image shows Christine inside the market, a clean, neat, well-inventoried store. Today, the second and third generations of the Tosches family own and operate the Italian Kitchen at the corner of Main and West Chestnut Streets, maintaining the family tradition of being a small grocery store featuring Italian and Swedish specialties and serving delicious home-cooked meals. (Courtesy of the Tosches and Zibelli families.)

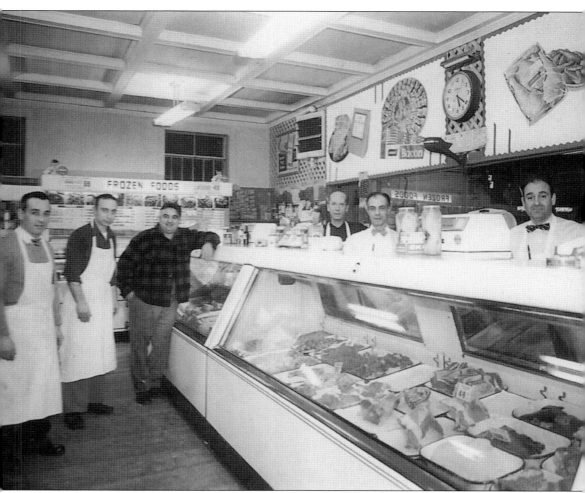

A Brockton landmark for many years, the Pleasant Market was located at 66 Pleasant Street in close proximity to the Central Fire Station and a short distance off Main Street. The Zibelli family owned this market, and, like most markets of this type and this time, employed many family members. In some cases, work in the family store was the only job a person had, or in many cases, it was the job to return to when one was finished with his or her shift in a factory in the city. Young and old members of the family always had a job to do in these family-run establishments. Standing around the well-stocked meat case at the Pleasant Market are, from left to right, "Little" Tony, Austie Zibelli, an unidentified customer, Jim Lynch, Anthony Zibelli, and Donald Treworgy. (Courtesy of the Tosches and Zibelli families.)

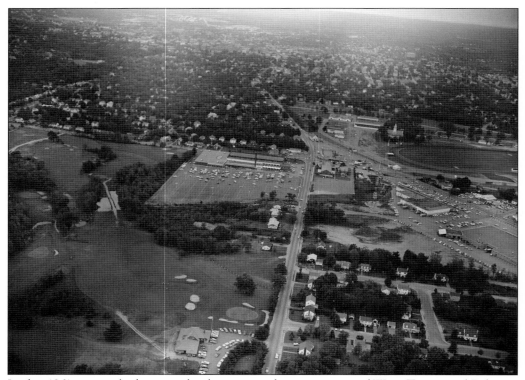

In this 1961 image, the business development at the intersection of West, Torrey, and Belmont Streets seems light compared to today. At the upper left is Kings department store in the old street railway carbarn; today, this is home to Price Rite. Across Torrey Street is Our Lady of Lourdes Church, and the large flat-top building at the extreme right is Sears. In between the church and Sears is the Brockton Public Market, located where present-day Staples is. The fairgrounds are to the upper right. (Courtesy of the Stanley A. Bauman Photograph Collection, Stonehill College.)

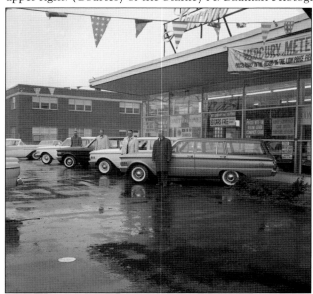

Fitzmaurice Motor Sales, today's Champion Lincoln, was Brockton's Lincoln-Mercury dealer. Pictured on October 24, 1960, are unidentified salesmen with four Comet station wagons set for delivery to Tedeschi's markets. New in 1960, the Comet was not sold under a parent brand but through Mercury dealers; it had been scheduled to be released under the Edsel nameplate before that brand's decline. (Courtesy of the Stanley A. Bauman Photograph Collection, Stonehill College.)

Among Brockton's well-known taverns was the Paddock, located at 38 Centre Street. In this 1949 photograph, the newest technology of the era is advertised in the window—television! Flanagan's Music store and teaching studios were located above the bar. At the far right in the picture is the center city branch of the post office. (Courtesy of the Stanley A. Bauman Photograph Collection, Stonehill College.)

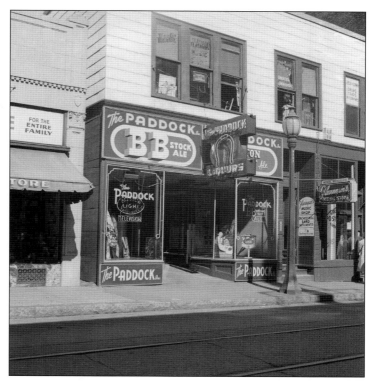

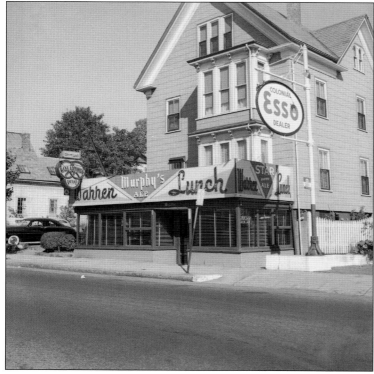

The Warren Lunch, managed by Christo Joseph, was located at 264 Warren Avenue near the intersection of Belmont Street. In this 1949 photograph, the establishment's sign also advertised Murphy's Ale and Star Ale. There were many such establishments about the city where retail space occupied the street-level storefront and residential space occupied the remainder of the building. (Courtesy of the Stanley A. Bauman Photograph Collection, Stonehill College.)

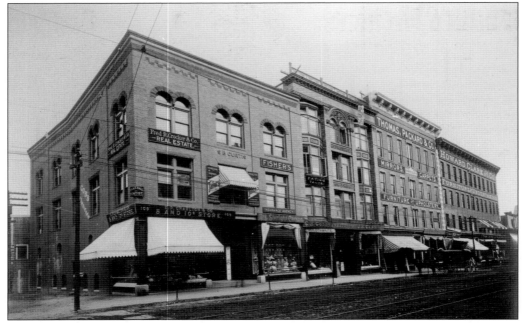

This row of business blocks on the west side of Main Street ran between High Street and today's Legion Parkway and is the largest group of buildings left downtown from the late 19th century. From left to right are the S.B. Curtis Block; the Goldthwaite Block, built in 1892; the Howard Block; and the Lyman Block. These four brick blocks are still standing today. The Goldthwaite Block was listed in the National Register of Historic Places in 1982. (Author's collection.)

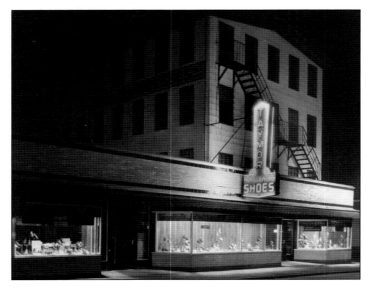

In 1911, Russian immigrant Aaron Taymor, who died in 1978, founded one of the region's largest retail shoe outlets, Taymor Shoes, on Montello Street. Taymor inventoried more than 300,000 pairs of shoes in 2,000 styles and widths and counted among its customers US presidents Eisenhower and Reagan as well as Massachusetts governor Michael Dukakis. (Courtesy of the Stanley A. Bauman Photograph Collection, Stonehill College.)

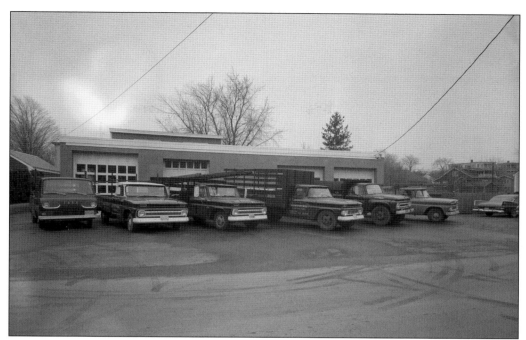

In 1929, G. Arthur Moberg, a prominent member of Brockton's Swedish community, founded his own roofing business after having been in the employ of C.F. Dahlborg and Sons as a roofer. In 1946, his son George A. Moberg joined the firm and assumed leadership of the firm upon his father's death in 1950. This 1967 image shows a sizable fleet of trucks in front of the company's Carroll Avenue facility. (Courtesy of the Stanley A. Bauman Photograph Collection, Stonehill College.)

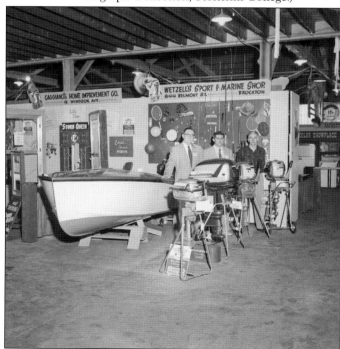

Before the days of large chain stores, like Dick's Sporting Goods and Modell's, Brockton was home to a number of small family-owned sporting good stores, such as A.C. Grady's, Brockton Sporting Goods, Marble Hardware and Sporting Goods, and Wetzell's. Pictured here are employees of Wetzell's at the 1956 home show with several of their marine specialties, including boats and outboard motors. Owner Rudy Wetzell and his wife, Marion, were sponsors of several Brockton youth sports teams. (Courtesy of the Stanley A. Bauman Photograph Collection, Stonehill College.)

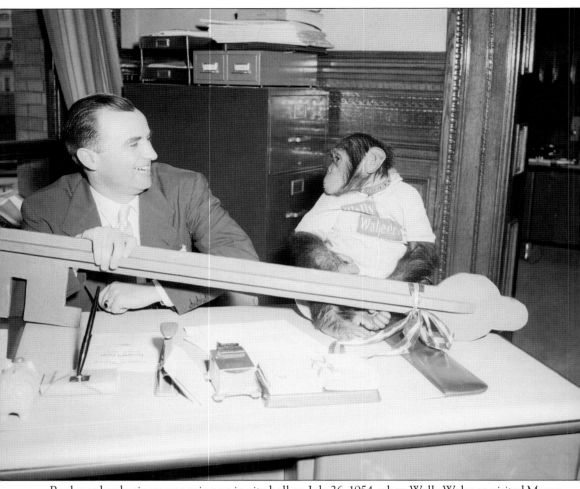

Real monkey business was going on in city hall on July 26, 1954, when Wally Waleeco visited Mayor C. Gerald Lucey in his office. Wally was promoting the famous Waleeco candy bar, manufactured by Brockton's F.B. Washburn Candy Corporation, a city institution since 1856. (Courtesy of the Stanley A. Bauman Photograph Collection, Stonehill College.)

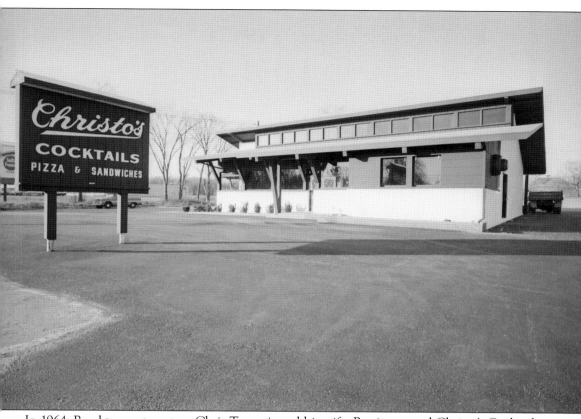

In 1964, Brockton restaurateur Chris Tsaganis and his wife, Bessie, opened Christo's Cocktail Lounge and Restaurant on Crescent Street. Already popular and well known from his downtown restaurant Peter's Lunch, Tsaganis moved to a relatively desolate area, as this picture indicates, and built his new facility, which has been expanded several times over its nearly 50-year history. (Courtesy of the Stanley A. Bauman Photograph Collection, Stonehill College.)

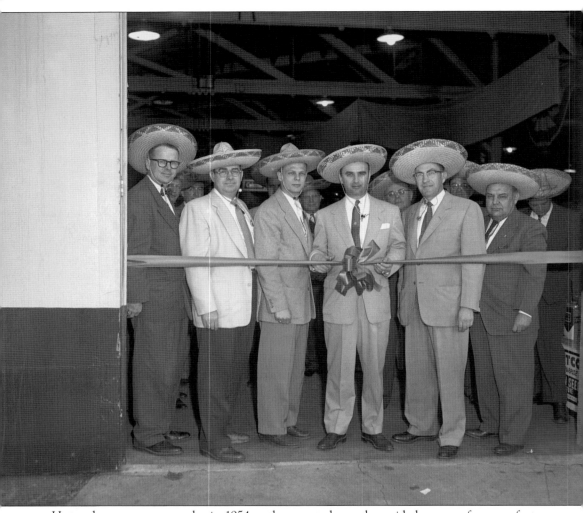

Home shows were as popular in 1954 as they are today and provided a venue for manufacturers to showcase the latest in products. The Brockton Chamber of Commerce prepares for its show opening with a ribbon cutting by members donning sombreros. From left to right are Gordon Fyhr, First Ward councilor; Reginald Plourde, show director; Richard Samuelson, assistant building inspector; Mayor Gerald Lucy; Richard Bullard, show chairman; and C. Hazard Beckford, chamber president. (Courtesy of the Stanley A. Bauman Photograph Collection, Stonehill College.)

Imagine a loaf of bread delivered to one's doorstep for about 20¢ a loaf! That was the average price for bread in 1954, and bakeries, such as Hathaway Bakeries on Perkins Avenue, provided home delivery. In addition to bread, other baked goods were available. Hathaway succeeded the firm of A.B. Hastings in the Perkins Avenue and East Market Street block. (Courtesy of the Stanley A. Bauman Photograph Collection, Stonehill College.)

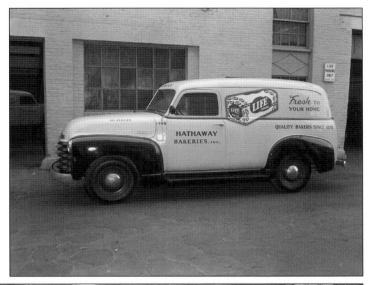

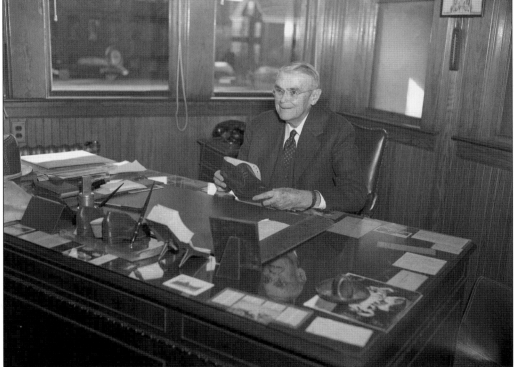

One of the last of the old-time shoe manufacturers was Perley G. Flint of the Field and Flint Company. Field and Flint began as the Burt and Packard Company in 1857. In 1927, Field and Flint's Footjoy golf shoe became the official golf shoe of the American Ryder Cup team. In 1957, a year before Flint's death, the Stone and Tarlow families purchased Field and Flint, and in 1970, the company officially became known as FootJoy, Inc. FootJoy, the last shoe manufacturer in Brockton, closed its Brockton plant in 2009, ending an industry created by Micah Faxon 198 years earlier. (Courtesy of the Stanley A. Bauman Photograph Collection, Stonehill College.)

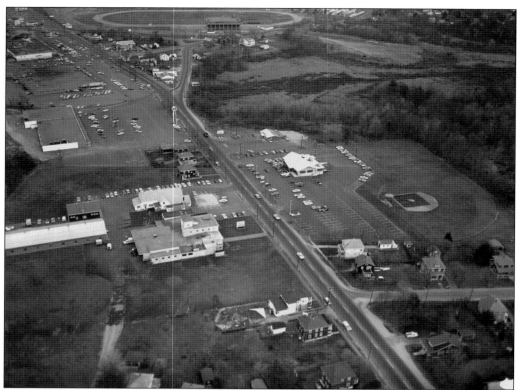

One popular location for Brocktonians, both young and old, was Producer's Dairy. A cooperative dairy to provide value to small local farmers, the dairy bottled and delivered milk and dairy products house to house from this location pictured on the right in the above photograph. The dairy also had a small restaurant and ice cream parlor on location. Eventually outgrowing the restaurant, the dairy built a new facility across the street, pictured below. This restaurant became Bickford's, and today, the site is a vacant lot. In the upper right of the picture is where Brockton High School and Campanelli Stadium are currently. (Both, courtesy of the Stanley A. Bauman Photograph Collection, Stonehill College.)

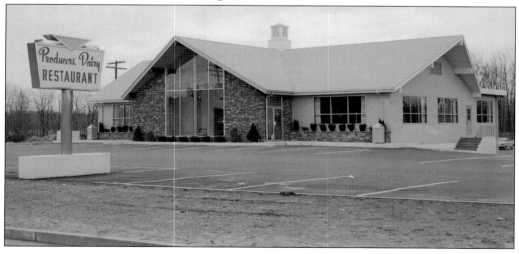

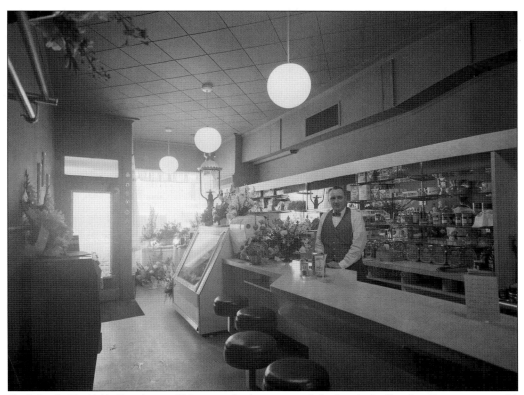

On March 23, 1960, Stanley and Virginia Carlson opened Carlson's Coffee Cup Restaurant at 30 West Elm Street. Stanley is seen here behind the counter of the shop, which is festooned with congratulatory floral displays. A good inventory of crackers, condiments, and canned hams line the shelves behind the counter. (Courtesy of the Stanley A. Bauman Photograph Collection, Stonehill College.)

Founded by William Rosenberg, the first Dunkin Donuts opened in 1950 in Quincy, Massachusetts. This 1964 photograph shows the interior of Brockton's new Dunkin Donuts shop. At the time of its opening, donuts were being sold for 75¢ per dozen and coffee was 10¢, and the shop's offerings were limited. Today, Dunkin Donuts is an international corporation with a menu the local coffee shop never dreamt of. (Courtesy of the Stanley A. Bauman Photograph Collection, Stonehill College.)

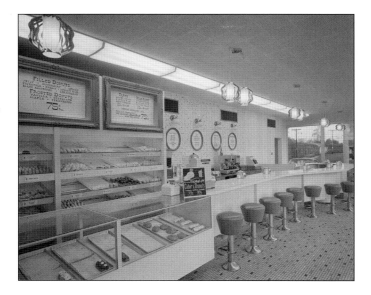

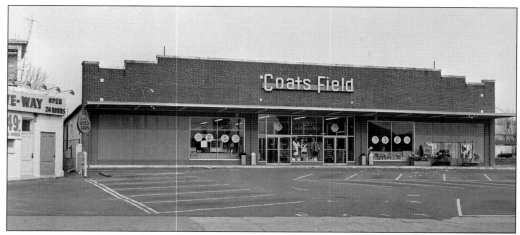

Located on North Main Street just north of downtown was Coats Field department store, a member of the Zayre's family of stores. Many of the independent retail department stores, large and small, closed with the advent of the areas malls. Famous Brockton names were Dave's 5 & 10, Fraser's, Ganley's, Gilchrist's, Mammoth Mart, King's, and others. (Courtesy of the Stanley A. Bauman Photograph Collection, Stonehill College.)

When ink came in bottles and not cartridges; when onionskin, thesis paper, and carbon paper were office staples; and when the mimeograph machine and manual typewriter were king, every city or major town had a stationery store to meet those office needs and more. In Brockton, Bailey's at 57 Main Street was the place to go. This 1954 image shows a well-stocked store with what would, in all likelihood, be obsolete items about the office today. (Courtesy of the Stanley A. Bauman Photograph Collection, Stonehill College.)

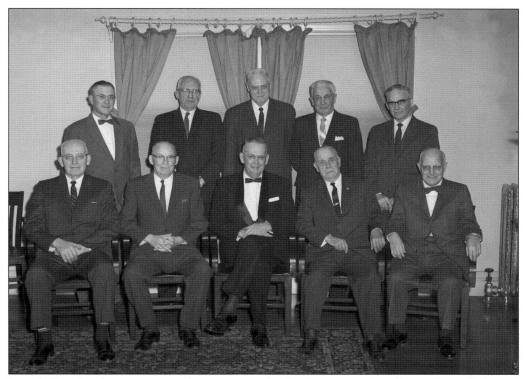

Long before the electronic networking options of today, business and professional people formed such entities as the Commercial Club. This group worked for the common good of city business in a social setting. In this photograph are the living past presidents in 1962. From left to right are (first row) Warren S. Keith, Harold V. Lawson, Ralph C. Paine, L. George McLeod, and attorney George Wainwright; (second row) Dr. Eldon F. Egger, Frederick W. Popo, Raymond W. Porter, Herbert C. Otterberg, and John D. Frates. (Courtesy of the Stanley A. Bauman Photograph Collection, Stonehill College.)

Businesses working together are a crucial cornerstone to the success of any city, and Brockton has had many strong organizations for such cooperation, including the Campello Business Association. On March 7, 1960, the association installed its new officers; from left to right are Martin Fireman, president; Edwin Ditchett, vice president; Richard Cudmore, secretary; and Elroy Ostlund, treasurer. (Courtesy of the Stanley A. Bauman Photograph Collection, Stonehill College.)

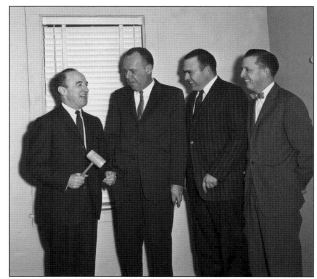

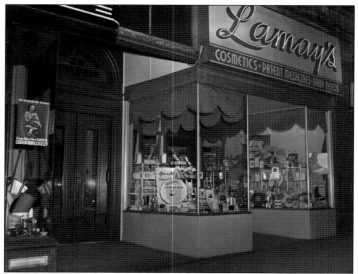

At a time when most businesses were locally owned and operated, Lamay's perfumery, located in the historic First Parish Building on Main Street at the corner of Green Street, was owned by J. Harold Krasnoff, a resident of Roslindale. This 1947 image also indicates that the store carried patent medicines and baby needs. (Courtesy of the Stanley A. Bauman Photograph Collection, Stonehill College.)

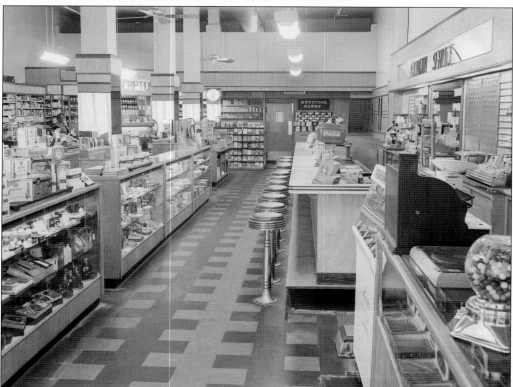

In 1950, Benjamin Iris opened a new pharmacy in the Cook Building on Main Street opposite Belmont Street. As was still the custom of the times, the pharmacy included a lunch counter and soda fountain area. Other tenants of the Cook Building at the time were the Joseph Ganley Company and the Victoria Louise Dress Shop. On the upper levels were the offices of attorney Eden Townes and physicians William Arnone, Arthur Hassett, Edward Gilmore, Joseph Berkowitz, and others. (Courtesy of the Stanley A. Bauman Photograph Collection, Stonehill College.)

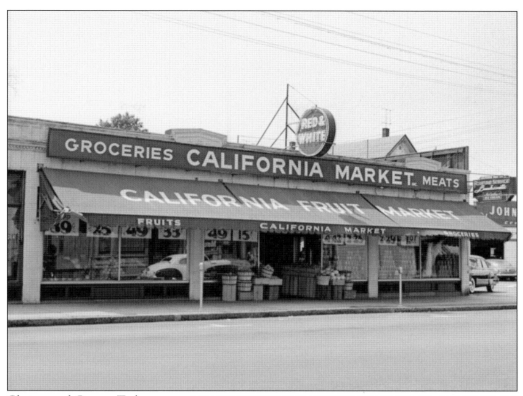

Christy and George Tasho owned the California Fruit Market at 100 North Main Street. These 1951 images of the exterior and interior show a well-maintained, fully stocked grocery store. In 1951, Brockton had 20 fruit markets and 112 grocery stores, mostly mom-and-pop neighborhood stores. The A&P Company had seven locations, and C.F. Anderson's had three; all others were one-location firms. These neighborhood stores were the nucleus of the community, the place to gather news and to spread gossip, and a place for the local kids to hang out after school. Many offered credit to their customers, and some offered home delivery. (Both, courtesy of the Stanley A. Bauman Photograph Collection, Stonehill College.)

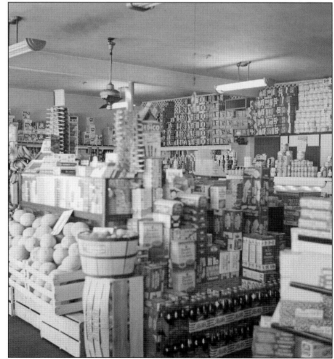

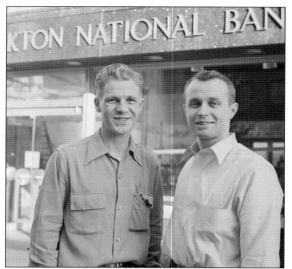

Before the megabanks of today, most banking was local and such was the case with Brockton National Bank, which, at one point, had 12 branch locations in the Brockton area. Pictured in this 1953 image are Gerald Johnson (left), who served as a bank auditor, and Frederick Lincoln, who was the manager of the West Side branch at the time. Lincoln later became vice president of all branch locations. (Courtesy of the Stanley A. Bauman Photograph Collection, Stonehill College.)

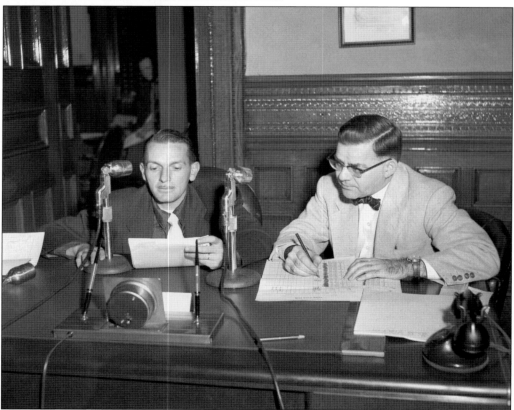

Radio station WBET, owned and operated by the *Brockton Enterprise and Times*, hence the station's name, was the local source of broadcast news for decades. Among the station's noted personalities were Arthur "Doc" Jones (left) and Ken Dalton, shown broadcasting 1955 election results from the office of city clerk Thomas J. Mullins. (Courtesy of the Stanley A. Bauman Photograph Collection, Stonehill College.)

On September 18, 1957, Mayor Hjalmar Peterson (right) welcomed Boston Red Sox great Ted "Teddy Ballgame" Williams to Brockton. Five days later, on September 23 in Washington, Williams secured the 1957 batting title, hitting .383 to Mickey Mantle's .365. A pair of Williams's shoes is a part of the Brockton Historical Society's celebrity shoe collection. (Courtesy of the Stanley A. Bauman Photograph Collection, Stonehill College.)

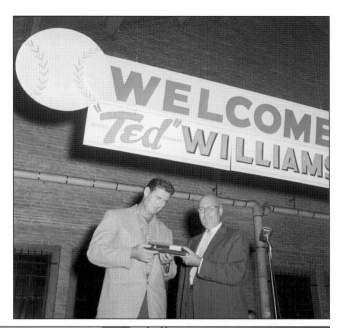

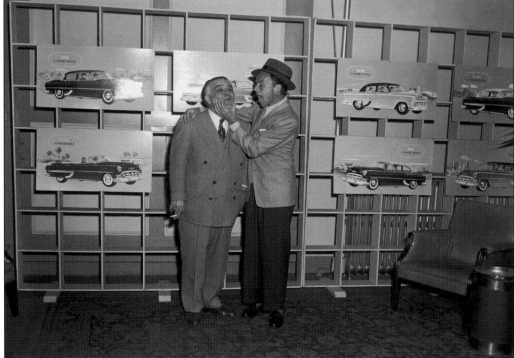

Among Brockton's well-known car dealers was A. Edward Lalli, and among Lalli's famous friends was crooner Frank Sinatra. In 1953, while on the nightclub circuit in Boston, Sinatra took a side trip to Brockton to surprise his longtime friend. Pictured here in the car dealer's Chevrolet showroom on North Main Street, Sinatra (right) has a jokingly strong grasp on his friend's neck. (Courtesy of the Stanley A. Bauman Photograph Collection, Stonehill College.)

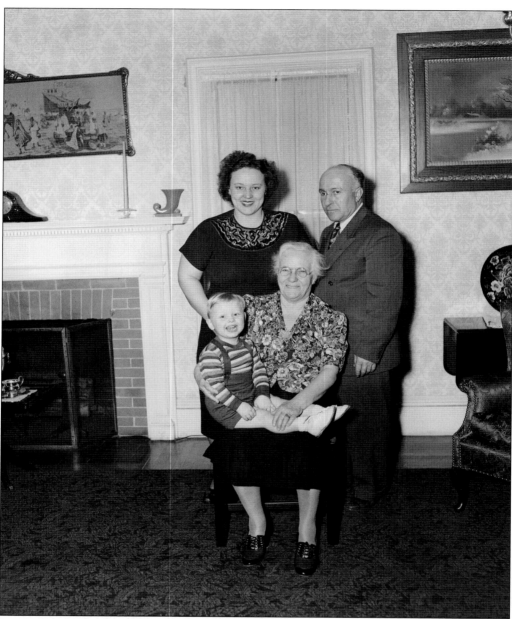

In 1881, the first Lebanese immigrants settled in Brockton and worked in the shoe factories. Prominent names in the community came out of this immigrant group: Asiaf, Khoury, Issa, George, Asack, and Mather, as well as others. Pictured in 1948 are (seated) Mary Asiaf and her great-grandson Robert Ray Haglund; (standing) Mildred Asiaf Haglund and her father, Peter Asiaf. Like many in his family who have served their city so long and well, Robert is today a city dentist and prominent in many community organizations. (Courtesy of the Stanley A. Bauman Photograph Collection, Stonehill College.)

Two

CHAMPIONS OF BRICK AND MORTAR

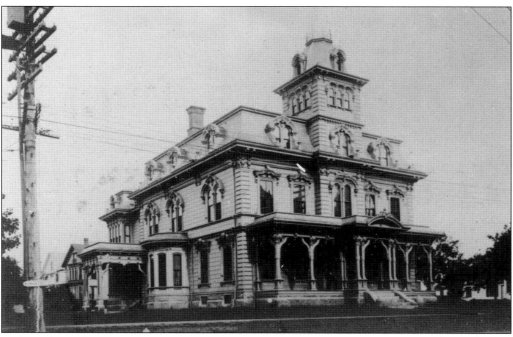

Built in the architectural style known as Second Empire, the home of Daniel S. Howard at the corner of Main and Pleasant Streets was perhaps the largest and most ornate house ever built in the city. A major shoe manufacturer in North Bridgewater and Brockton from 1848 to 1888, Howard employed thousands and was one of the town's wealthiest citizens. Daniel Waldo Field worked for Howard as a clerk until opening his own firm in 1881. (Courtesy of the Brockton Public Library.)

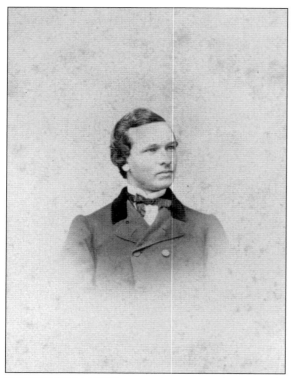

One of Brockton's prominent men of the 19th century was Dr. Edgar Everett Dean, shown at left, born in North Easton, Massachusetts, on December 17, 1837. Dean graduated from Harvard Medical School in 1861 and came to Brockton to succeed Dr. Alexander Highborn after brief work in Boston. A Republican, Dean left the party and ran twice, unsuccessfully, as a Democrat against John D. Long for Congress. He served on the city's board of aldermen in 1882 and, in 1888, rejoined the Republican cause. Gen. Benjamin Butler, while governor of Massachusetts, appointed Dean to the state board of health. Dean died in 1895. His beautiful home, shown below, on the north side of Green Street, was constructed in the Shingle-style of the period and designed by architect Wesley Lyng Minor. This home, later the Hall Funeral Home, is listed in the National Register of Historic Places. (Both, courtesy of Christine and Donald Newman.)

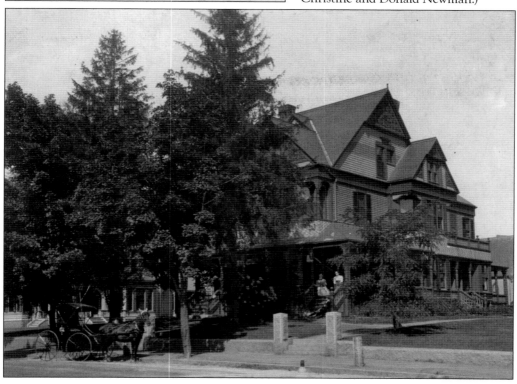

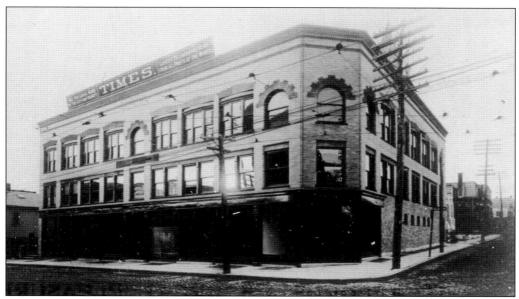

In 1895, William L. Douglas launched the *Brockton Times* newspaper and, in 1897, built it a home at the corner of Main and Pleasant Streets, shown above. Local architect Wesley Lyng Minor, who had established himself as the area's premier architect, designed this yellow brick building. The *Times* merged with the *Brockton Enterprise* in 1934. Minor also designed Douglas's elegant West Elm Street manse, pictured below. This red granite and brownstone home bore many of the architectural elements found in city hall. The Douglas mansion was in all accounts Minor's masterpiece in masonry residential construction. Minor also designed the stately Kingman house across from the public library and, in recent memory, the location of the Sampson Funeral Home. The Douglas home later served as the Murdoch Hospital, but a fire severely damaged it, resulting in the demolition of all but the first and second floors, which remain today. (Both, courtesy of the Brockton Public Library.)

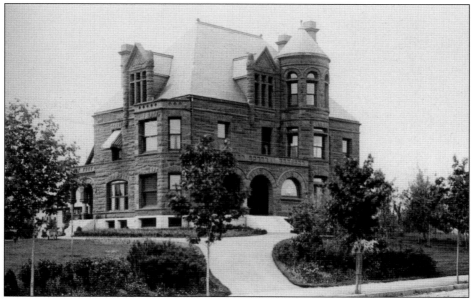

Simple country elegance can best describe the home of Daniel Waldo Field on North Main Street, pictured above. Field's home, like many belonging to his contemporary factory owners, was in close proximity to the factory. When asked about his modest home compared to those of his contemporaries, Field remarked, "If it was good enough while I was making my way in this world its good enough now." The home was razed to make way for the parking lot of HarborOne Credit Union. Below, D.W. Field and his wife, Rosa, relax on a bench outside of the Hotel Raymond, their Pasadena, California, retreat. Field was one of the men instrumental in the founding of the Tournament of Roses parade, and he and Rosa made the Raymond their winter retreat though they owned acreage a short distance away where they grew oranges, avocados, and lemons. (Above, author's collection; below, courtesy of the Brockton Public Library.)

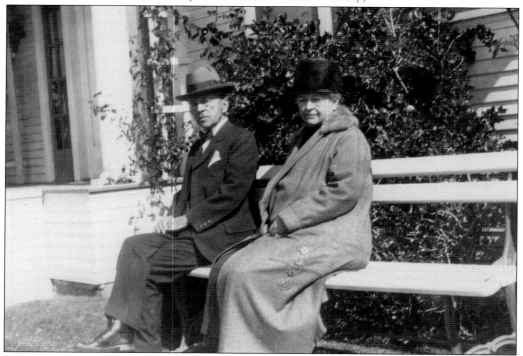

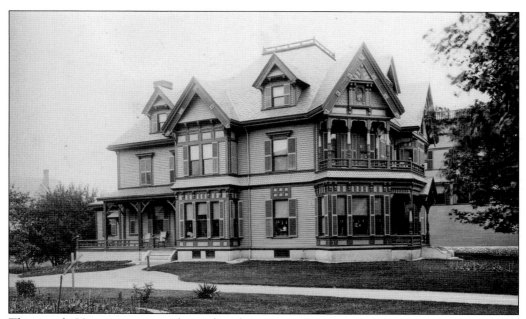

This stately Victorian cottage, located at the corner of Main and Allen Streets approximately where the YMCA is on Main Street today, was the home of shoe manufacturer Robbins B. Grover, president of R.B. Grover & Company and also president of the F.B. Washburn Company. Grover, a native of Bethel, Maine, fought with the 13th Maine and attained the rank of captain with the Union Army during the Civil War. He was also involved in the capture of the rebel stronghold at Mustang Island, Texas. After the tragic explosion at his shoe factory, Grover spent his remaining lifetime in assuring care for the victims' families. (Author's collection.)

This view shows Main Street in Campello looking south from Grove Street, with construction going on and both automobiles and horse and wagons on the roadway. On the left with the flags over the entrance is the Shepard Market Company, while across the street is the paint store of Gustaf A. Lindskog, later to become Holmstrand's and today home of Jeanno's restaurant. (Courtesy of the Brockton Public Library.)

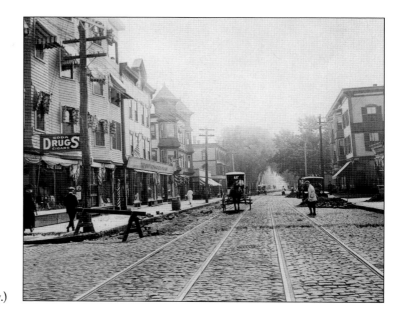

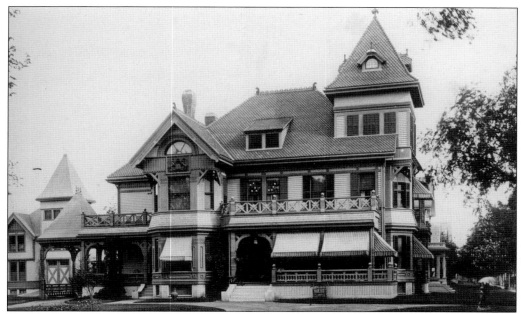

Wealth derived from the shoe industry was displayed ostentatiously in the homes of many of its successful men, like the home of Brockton's first mayor, Ziba Cary Keith, shown above. This home was located on the south corner of Main and Plain Streets and faced onto Main Street opposite Clifton Avenue. The carriage house on the far left of the image is today an apartment building. On the opposite corner of Plain Street stood the homes, shown below, of George Eldon Keith (left) and his brother Myron Lee Keith. The homes of both George E. and Ziba C. Keith were designed by Brockton architect Wesley Lyng Minor. Minor added unique touches of embellishment to his work; for example, under the half-round window on the side gable of the house above is a bas-relief panel of the Keith family's coat of arms. (Both, author's collection.)

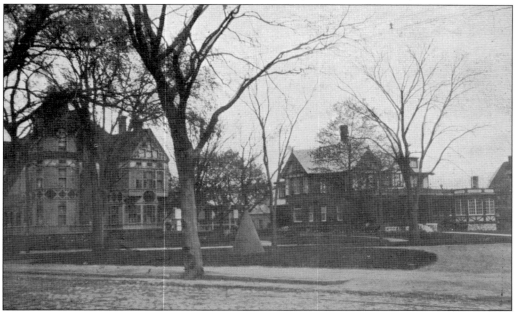

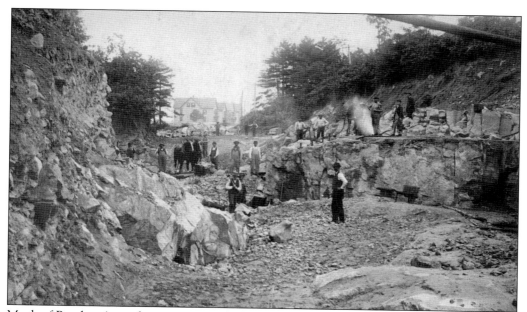

Much of Brockton's northern area is marked by ledge, which made road building a chore in the days before modern equipment. This 1891 view shows a crew with pneumatic drills, shovels, sledgehammers, and wheelbarrows building Montello Street just south of Ames Street. Black powder or nitroglycerin was most likely used in this project. (Courtesy of the Brockton Public Library.)

Flatcars loaded with granite blocks line the street-level railroad tracks, as crews erect one of the arch bridges that eliminated the grade crossings in Brockton. The wooden trestle on the left was built to raise the track level to its new height. Note the gin poles, cables, and derricks erected to accomplish the task. (Courtesy of the Brockton Public Library.)

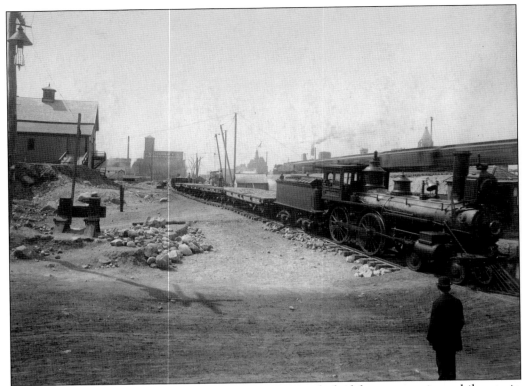

Shown above, a steam locomotive sits on temporary tracks laid for construction, while a train passes by on the newly elevated rail bed, with the tower of city hall visible in the background. The smokestack of the Edison plant is also visible in the background and so is the tower of the Central Methodist Church on Church Street. In the view below, the Victorian railroad station of the Old Colony line sits at street level, while the granite arch in the foreground allows for safe passage of vehicles and pedestrians. A temporary timber walkway provides access from the station to the new tracks. In 1896, Brockton became the first city in the nation to eliminate grade crossings. (Both, courtesy of the Brockton Public Library.)

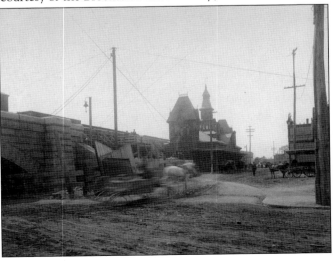

At the corner of Main and Belmont Streets stood the imposing home of Rufus Packard Kingman. Born in 1821, Kingman was a dry goods merchant until 1854, when ill health forced him to give up that job. Kingman built the city's first brick commercial block and was a leading figure in banking. He was also vice president of the newly formed Brockton City Hospital Corporation in 1890. Kingman died in 1894, and his funeral was held from this home. (Courtesy of the Brockton Public Library.)

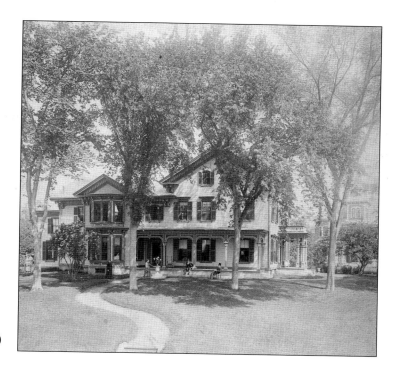

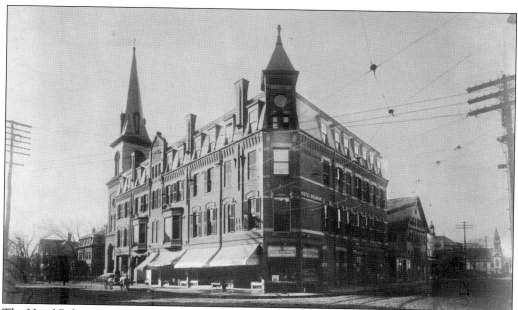

The Hotel Belmont at the southwest corner of Main and Belmont Streets was an imposing structure featuring retail space at street level and hotel accommodations above. Old St. Patrick's Church is immediately adjacent, and looking down Belmont Street can be seen the rounded cupola of the courthouse and the spire of the First Baptist Church, then located at the corner of Warren Avenue and Belmont Street. (Author's collection.)

Located just off Main Street at 28 Centre Street was the Joslyn Block. This block was home to the grocery store of Frank S. Snow and also the millinery shop of Edith Brett Creasy. Centre Street was one of the main commercial districts off Main Street. Many of the buildings in this area have been demolished, and the area is being considered for new development. (Author's collection.)

The Bryant Building sat prominently at the northeast corner of Main and Centre Streets and was home to the Brockton National Bank. Above the bank were the photographic studios of David T. Burrell, the photographer of many of the images within this volume. The building to the left of the Bryant Building is the Enterprise Building, designed by Wesley Lyng Minor. While the Bryant Building is gone, the Enterprise Building still remains. (Author's collection.)

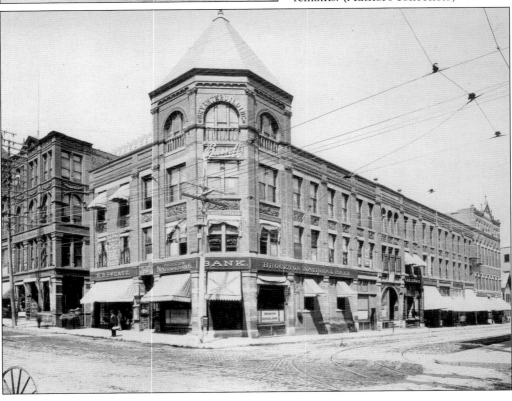

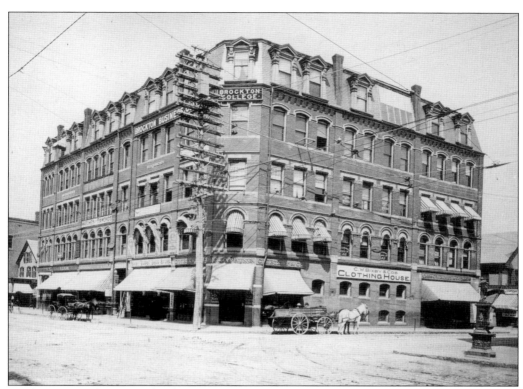

At the corner of Main and School Streets was the Bixby Block. Designed in 1883 by city hall architect Wesley Lyng Minor in the style of the Second Empire, this block housed a variety of retail establishments as well as the Brockton Business College. In later years, the popular Sylvia Sweets Tea Room was located in this block. Fire destroyed much of the original block in the 1970s, but it was rebuilt in a similar style. (Author's collection.)

In 1890, the Brockton Savings Bank Building and Canton Hall was constructed on the northeast corner of Main and Court Streets. In addition to the bank, several retail establishments populated the street level. The tower of the Porter Congregational Church can be seen in the background. Fire consumed the upper floors of this structure, and today, the lower level remains as the home of Brockton Community Access Television. (Author's collection.)

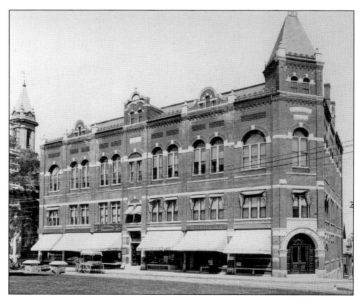

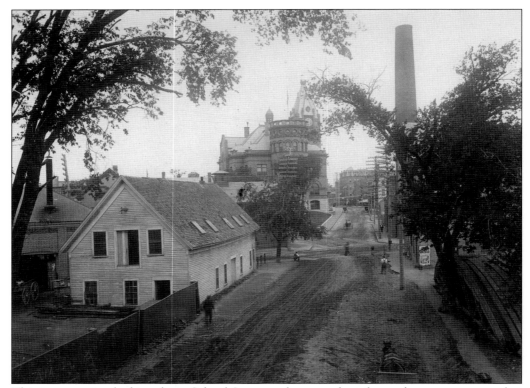

This is a rare view looking down School Street to the west when the roadway went over, rather than under, the railroad. In the distance are city hall and the smokestack of the Edison plant, now home to the Metro South Chamber of Commerce. Note the arched trusses leaning against the tree on the right; these were the forms for the arches on the railroad bridges being constructed at the time. (Courtesy of the Brockton Public Library.)

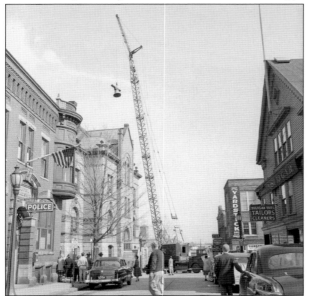

With the cupola weakened by Hurricane Carol in August and Hurricane Edna in September 1954, the bell perched atop city hall was lowered by the Hallamore Company on October 11 of that same year. Currently, it rests outside the entrance to city hall. On the left is the Brockton Police Headquarters, and on the right is the meeting hall of Post 13 of the Grand Army of the Republic. (Courtesy of the Stanley A. Bauman Photograph Collection, Stonehill College.)

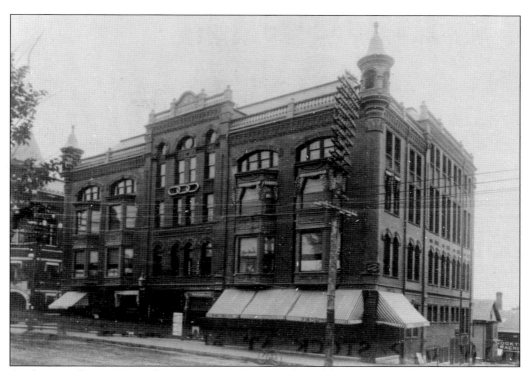

At the top of Main Street, between Court Street and Franklin Avenue, John Jay Whipple built the Whipple-Freeman Block, shown above, on the site of the home of his father-in-law, Franklin Otis Howard. Whipple was prominent in the affairs of Brockton and served as its chief executive four times. Whipple was also well known in the affairs of several fraternal organizations. His house on Green Street was the first in the world electrified by a three-wire underground system. Under Gov. Oliver Ames, he served as the state's commissioner of pharmacy. It was while he was mayor that Brockton's railroad grade crossings were eliminated and that city hall was dedicated. In the 1960s, there was an unfortunate national mind-set to destroy the old, and not just Brockton, but the entire nation lost many irreplaceable structures. On Sunday, February 7, 1965, the Whipple-Freeman Building, shown below, was razed. (Both, courtesy of the Stanley A. Bauman Photograph Collection, Stonehill College.)

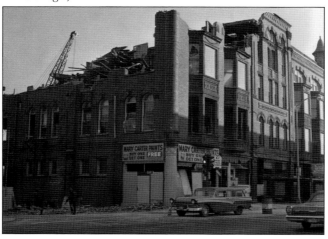

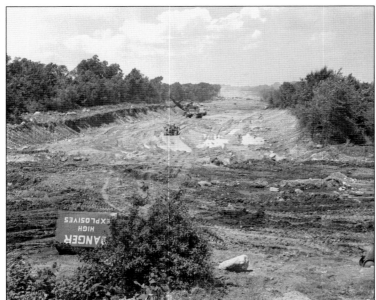

The construction of Route 24 from Fall River to Boston split many communities in two. This view, taken on June 24, 1954, is from Pleasant Street looking north and depicts the great swath cut through the city. As each section was completed, the new roadway opened in stages from exit to exit. (Courtesy of the Stanley A. Bauman Photograph Collection, Stonehill College.)

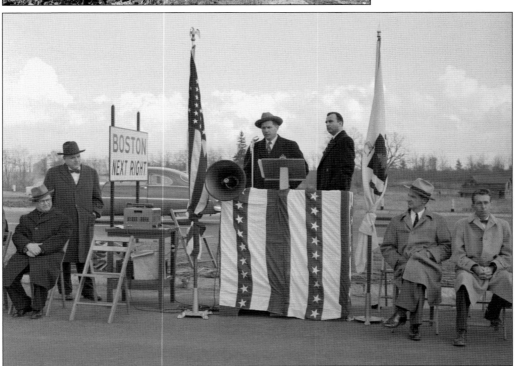

The "road to nowhere," as some called it, but officially known as the Fall River Expressway, Route 24, AMVETS Highway, opened the Brockton to West Bridgewater section on December 20, 1954. Officiating at the opening of this stretch was the governor's councilor Harold Allen of Brockton at the microphone with Mayor C. Gerald Lucey standing beside him and police chief John F. O'Connell Jr. and city councilor Joseph Downey seated on the right of the photograph. (Courtesy of the Stanley A. Bauman Photograph Collection, Stonehill College.)

Three

CHAMPIONS OF HEALTH AND PUBLIC SERVICE

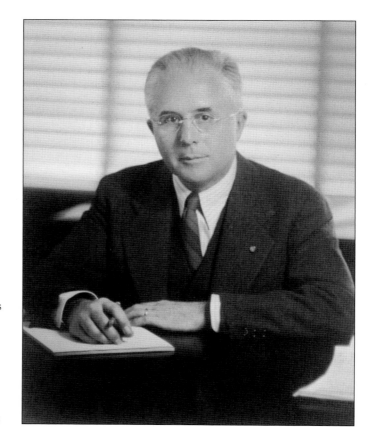

Paramount to Brockton's emergence as an industrial center was the attention given to power, especially electrical power to operate the shoe factories. Perhaps no man, other than Thomas Edison himself, did more to grow and promote electricity than Walter A. Forbush, pictured here. Forbush dedicated over 50 years of his life to the Brockton Edison Company, beginning as a young man in 1907. Many of the electrical service innovations in use today were a result of this man's leadership. (Courtesy of the Brockton Historical Society.)

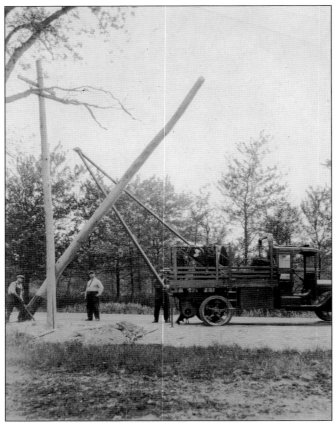

The Brockton Edison Company worked hard to grow its business, and it was hard work, as these two images imply. In the photograph at left, a crew is setting a pole—which was hard, backbreaking work—with only the help of a simple truck-mounted derrick. Below, the line crew strung lines from pole to pole and repairing downed lines in all weather conditions. Much of this work was done without thought of hazard. Brockton Edison also introduced appliance sales in the 1920s. The company sold its first electric refrigerator in 1924, selling 30 of them; its first electric range in 1926; and in 1927, more than 1,600 curling irons were bought. By the mid-1950s, refrigerator and range sales exceeded 2,000 of each annually, but curling irons had been discontinued. (Courtesy of the Brockton Public Library.)

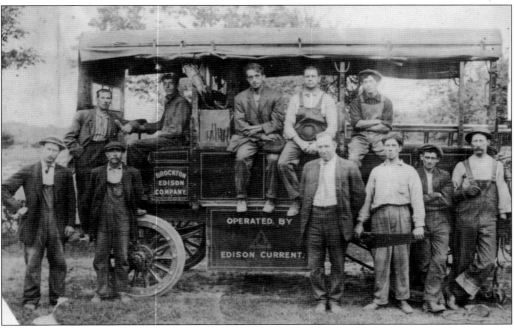

A downtown landmark for many years, the Edison plant on School Street had become obsolete by the 1920s and was used as a garage. On December 8, 1923, workmen undertook the lowering of the chimney. By December 21, they had reduced its height in half, and on December 29, the task of lowering the chimney to the height pictured at right was completed. The building still exists today. (Courtesy of the Brockton Historical Society.)

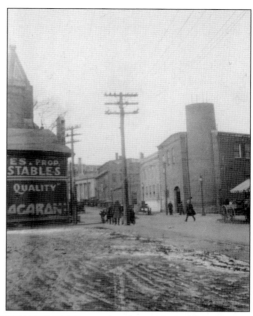

With tight budgets, the Brockton Police Department looked for ways to save money and in 1950 purchased a bullet-making machine in order to make ammunition for practice at quantities greater than they could afford to buy. Operating the machine are, from left to right, officer Warren Nelson, firearms expert Mark MacAdam, and Chief Richard Tonis. (Courtesy of the Stanley A. Bauman Photograph Collection, Stonehill College.)

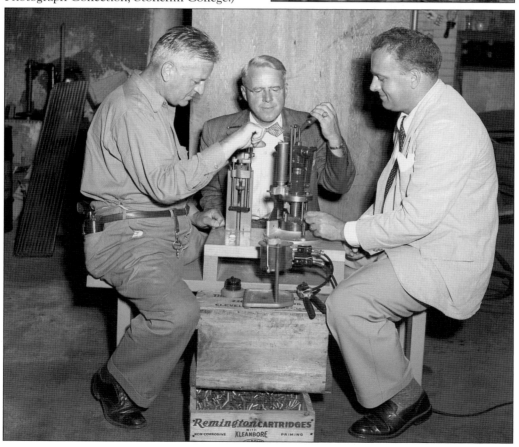

Like most 19th-century cities and towns, the indigent needed some form of public welfare, and the answer was the almshouse or poor farm. Brockton's almshouse was located where Massasoit Community College stands today. In 1880, about 33 people were full-time residents of the almshouse, costing the city $1.91 per person per week. In 1881, Brockton appropriated $8,000 for the care of the poor in the town. (Author's collection.)

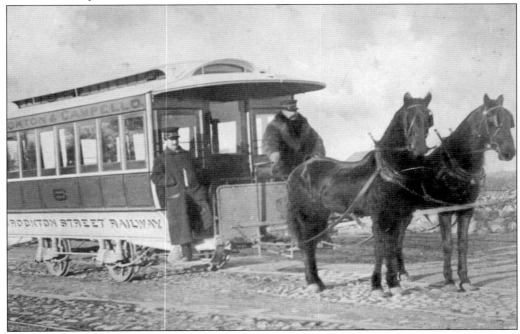

In 1881, the Brockton Street Railway Company began a horse-powered trolley service along Main Street. This image depicts that early mode of transportation. The arrival of Thomas Edison in Brockton and his desire to use the city as an experimental site spelled the end of the horse-drawn trolley, as Brockton became the second city in the nation—New York City was the first—to have electrified streetcars in 1881. (Courtesy of the Brockton Public Library.)

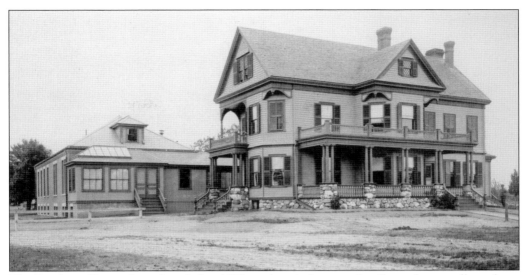

The Brockton Hospital was founded in 1896 as a hospital to care for all people, regardless of age, race, creed, or gender, and in 1897, the Brockton Hospital School of Nursing was established. Founded in a wood-frame house, shown above, on Centre Street in the city's East Side neighborhood, the institution grew to be the largest health care facility in the region. The hospital had a new and modern look in the 1950s, and the buildings shown below have been remodeled, expanded, and added to over the years. Today, the hospital is known as Signature Health Care Brockton Hospital and has 253 licensed beds and serves Brockton and 21 surrounding communities. Among the hospital's early benefactors were George E. Keith and Daniel Waldo Field. Today, the Brockton Hospital School of Nursing is the only remaining such hospital-based nursing school in Massachusetts. (Above, courtesy of Frank and Pearl Nelson; below, courtesy of the Stanley A. Bauman Photograph Collection, Stonehill College.)

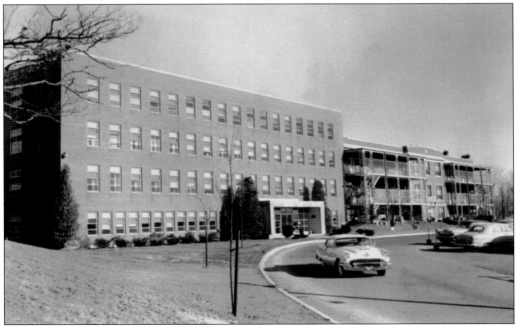

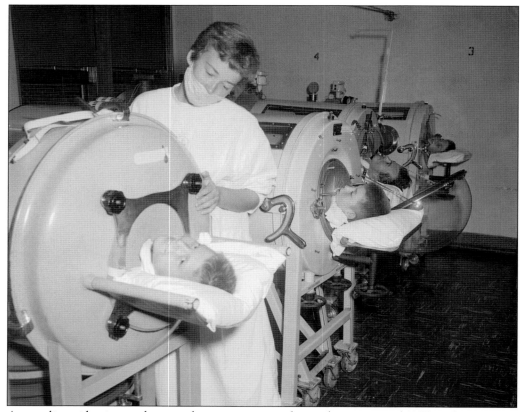

As a polio epidemic raged across the country, many knew the summer of 1955 as the "summer of fear." The Boston region recorded the second highest number of cases per 100,000 people in the country. This image, taken at Brockton Hospital, shows several victims of the disease in iron lungs, which help to assist in breathing. (Courtesy of the Stanley A. Bauman Photograph Collection, Stonehill College.)

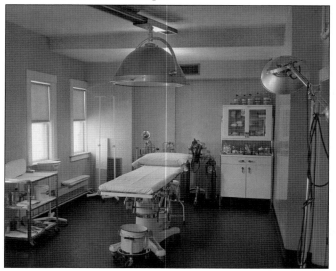

Dr. Joseph Phaneuf operated his own hospital on North Main Street, and this 1954 photograph displays what was at the time a state-of-the-art operating room, rather Spartan by today's standards. It was Dr. Phaneuf who brought Rocky Marciano into this world. On the night of January 27, 1956, his 68th birthday, Dr. Phaneuf delivered his 10,000th baby. (Courtesy of the Stanley A. Bauman Photograph Collection, Stonehill College.)

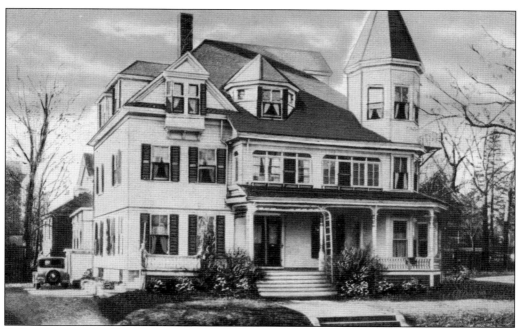

Before the growth of large corporate-run hospitals, many doctors established their own hospitals in large homes. Brockton had several of these hospitals that were owned and operated by doctors, such as the Moore Hospital at 167 Newbury Street. Dr. George A. Moore established the Moore Hospital, pictured here. The Goddard, Murdoch, and Phaneuf hospitals were among the other physician-owned hospitals in the city. (Author's collection.)

Among Brockton's well-known physicians was Dr. Henry J. Lupien, shown here still on the job at age 84 in 1965. Dr. Lupien began his medical practice in Brockton in 1909, which was interrupted by World War I in 1918 when he was called into the service of his country. He served as a first lieutenant in the Army Medical Corps and saw active duty in Europe. (Courtesy of the Stanley A. Bauman Photograph Collection, Stonehill College.)

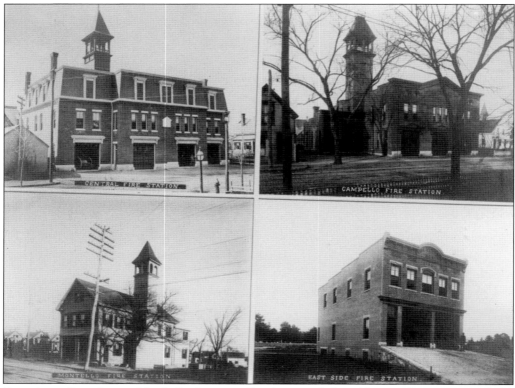

From its earliest days as North Bridgewater, Brockton prided itself on its fire service and the protection it offered the city. In the above 1898 image are, from top left, Central Station on Pleasant Street, the Campello Station, the Montello Station, and the East Side Station. The Central and Campello Stations are still in use, and the wood-frame Montello Station was replaced with a brick structure at the turn of the last century. Parked in front of the Frank White estate on West Elm Street is the elegant chief's car, complete with brass bell, in the early 20th century. (Above, author's collection; below, courtesy of the Brockton Public Library.)

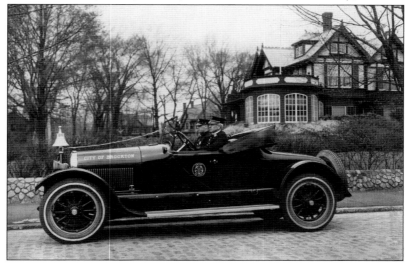

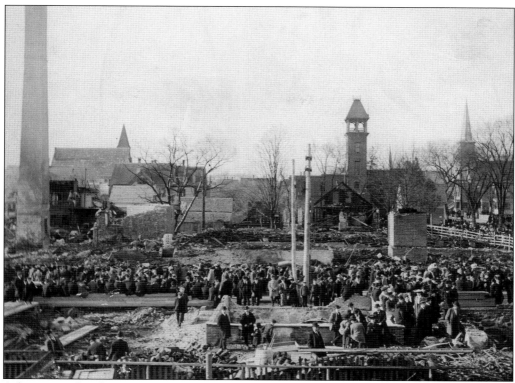

A large crowd gathers to view the devastation of the boiler explosion at the R.B. Grover shoe factory in Campello on March 20, 1905. A total of 58 people perished in the ensuing inferno. The factory chimney on the left and the tower of the Campello Fire Station and steeple of the First Swedish Lutheran Church to the right stand as silent sentinels to the disaster. (Courtesy of the Brockton Public Library.)

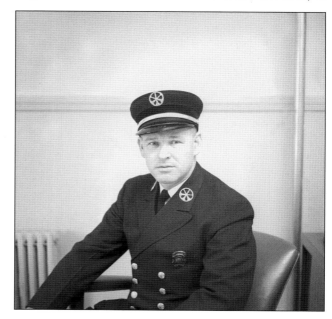

Edward "Sonny" Burrell, at the age of 26, was one of the fortunate firefighters to survive the March 10, 1941, tragic Strand Theatre fire in which 13 of his comrades died. Burrell, who went on to become the department's chief, was honored by being depicted kneeling with head down in the Strand Theatre Firefighters Memorial. Chief Burrell is the last surviving firefighter of this event, and he retired from the department in 1979. (Courtesy of the Stanley A. Bauman Photograph Collection, Stonehill College.)

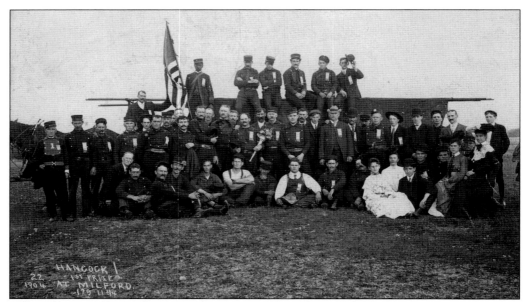

Before the age of horse-drawn steam engines and gasoline- and diesel-powered apparatus, the hand tub was a valuable piece of firefighting equipment. Pulled to the scene by men or horse, these pumpers would draw water from any nearby source with the brakes being operated by as many as 50 men. Pictured here in 1904 is the Hancock Company's tub after winning first prize in a muster. The Brockton Historical Society has two of the city's hand tubs on display in the William Donovan Fire Museum. (Courtesy of the Brockton Public Library.)

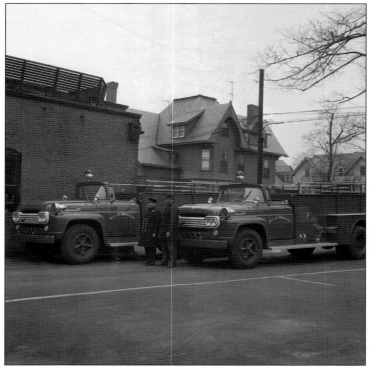

Fire chief Lawrence Lynch, left, and master mechanic Francis Dupuis look over two of Brockton's brand-new fire engines, Combination 3 and Combination 5; both pieces of equipment have a water capacity of 500 gallons. Note that neither piece of equipment has a roof over the cab; this was to allow the cab to serve as an observation and command post for the chief or commanding officer at the scene of a fire. (Courtesy of the Stanley A. Bauman Photograph Collection, Stonehill College.)

On February 21, 1958, Brockton's magnificent city hall was heavily damaged by fire, as shown in the image at right. This view shows firemen on the second floor following the fire. The opening to the second floor was sealed off after the fire but was recently restored to its original design. (Courtesy of the Stanley A. Bauman Photograph Collection, Stonehill College.)

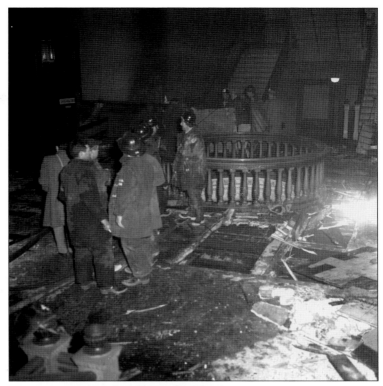

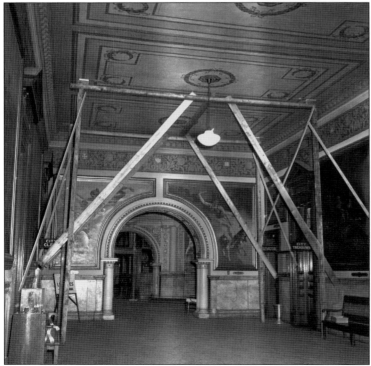

In the months after the fire, it was discovered that the ceiling in the main hall was weakened, and in the May 7, 1958, image at left, timbers shore up the elaborate ceiling. Regrettably, this ceiling was covered with a nondescript suspended ceiling. This hallway is adorned with paintings of the Civil War by F. Mortimer Lamb and Richard Holland. (Courtesy of the Stanley A. Bauman Photograph Collection, Stonehill College.)

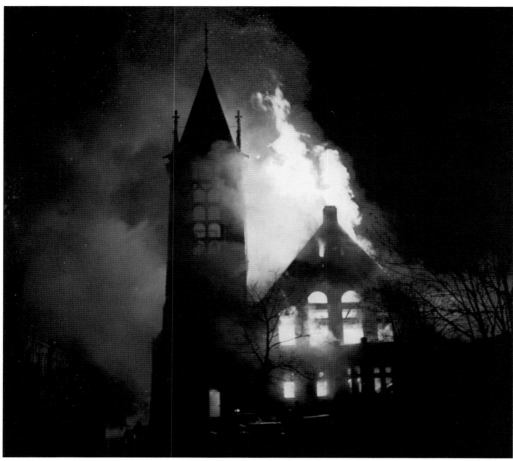

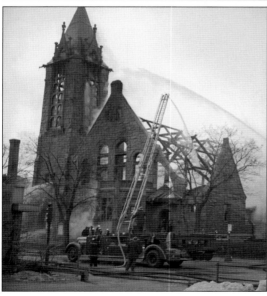

On February 19, 1965, Brockton's historic First Parish Church on Pleasant Street was totally consumed by fire despite heroic efforts. In the above photograph, flames light the night sky. The parish's earlier building, which stood at the corner of Main and Green Streets, had a similar ending. Ironically, this building was located next to the Central Fire Station. The land on which the church stood was once the training ground and muster field for soldiers fighting in the American Revolution. First Parish erected a new building on the site, which it occupied until several of the city's churches merged to form Christ Congregational Church. Mount Moriah Baptist Church occupies the Pleasant Street site today. (Both, courtesy of the Stanley A. Bauman Photograph Collection, Stonehill College.)

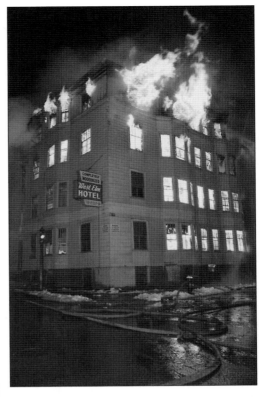

On February 16, 1970, flames shoot from the upper windows of the Redlands Apartment building at the corner of Warren Avenue and West Elm Streets (pictured at right), while firefighters below are silhouetted against the inferno. Four people perished in this fire, and a local 18-year-old was charged with four counts of murder and for deliberately setting fire to the dwelling. One person in the Redlands was never accounted for. In 1973, just two blocks away, the rambling Ardmore Hotel was destroyed by a fire in which five people lost their lives. A decade later, fire would claim lives and the 80-year-old Checkerton apartment building a short distance from these other two locations. (Both, courtesy of the Stanley A. Bauman Photograph Collection, Stonehill College.)

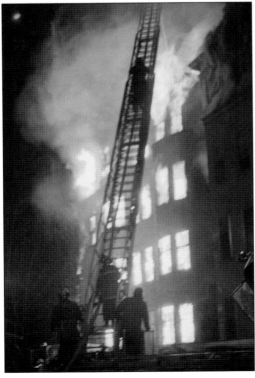

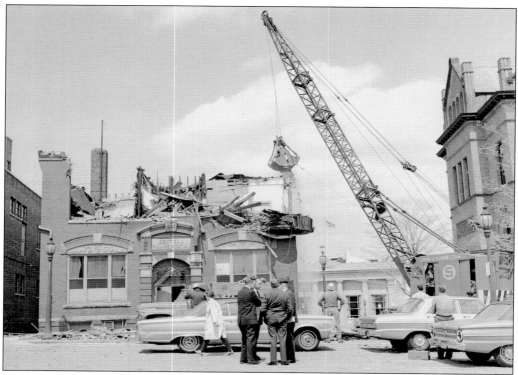

In 1968, Brockton's imposing police station opposite city hall was razed. This building had seen the likes of Sacco and Vanzetti occupy its cells. A new police station was built a short distance away on the site of the Old Colony railroad station, which had also been demolished in a wave of unbridled and, at times, thoughtless urban renewal. While more functional, the new police station lacked the architectural beauty and distinction of both its former home and that of the railroad station. (Both, courtesy of the Stanley A. Bauman Photograph Collection, Stonehill College.)

Four

CHAMPIONS OF THE ARTS AND EDUCATION

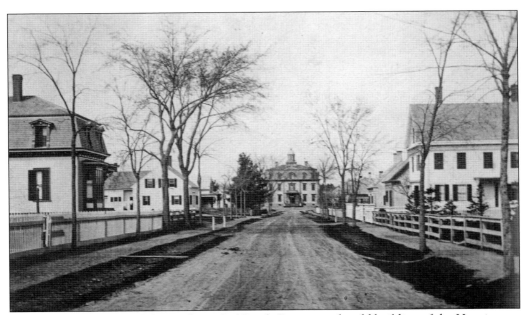

Sitting like a manorial edifice at the end of South Street was the old building of the Huntington School, which was replaced in the late 19th century by the brick and granite structure on the site today. Many of Brockton's prominent businessmen, including George E. Keith, were educated in this building. In later years, the Colonial homes along South Street were replaced by grander Victorians of the area's wealthy business class. (Courtesy of the Brockton Public Library.)

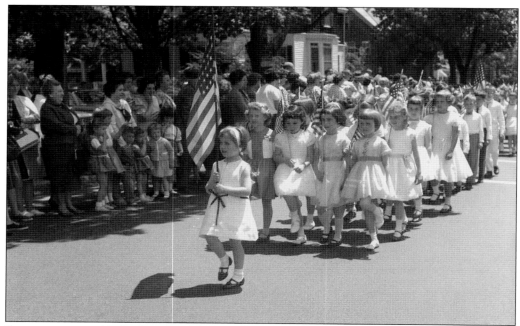

Every year since 1898, the schoolchildren at the Huntington School have held a Memorial Day parade. In years gone by, white dresses and white shirts were the order of the day. In this photograph of the 1963 parade, the leader with the flag is Kathleen Geiler, and behind her in the first row are, from left to right, Deborah Johnson, Patricia O'Reilly, Melissa Stimpson, and Lynne Balevich, all first graders at the school. (Courtesy of the Stanley A. Bauman Photograph Collection, Stonehill College.)

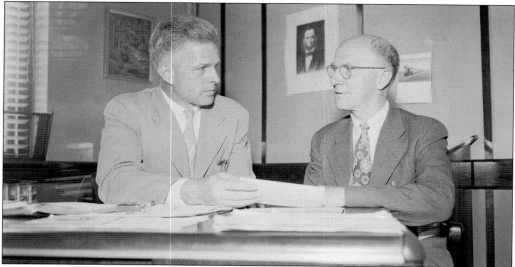

In 1947, Ralph S. Frellick (right) became the new headmaster at Brockton High School, succeeding Ralph W. Haskins (left). Frellick, a popular teacher at West Bridgewater's Howard High School and at Brockton, was active in the community and served as president of the Brockton Rotary Club in 1956 and 1957. He also took an active part in the National Association of Secondary School Principals. (Courtesy of the Stanley A. Bauman Photograph Collection, Stonehill College.)

From its wooden school building to its late-19th-century brick and granite structures to the newest of its schools today, Brockton has always taken great pride in its educational facilities and programs. Pictured at right in the north end of the city is the Perkins School, located at 19 Charles Street. Below is the beautiful yellow brick and brownstone-trimmed Whitman School on Manomet Street near Belmont Street. The Perkins School has long since closed, and the Whitman was recently closed, with a new owner being sought for the property. (Right, courtesy of the Brockton Public Library; below, author's collection.)

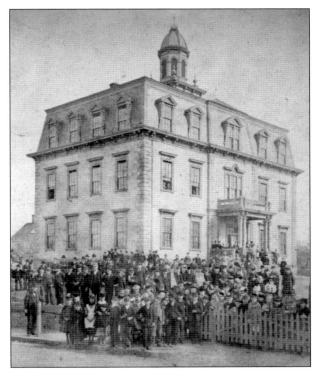

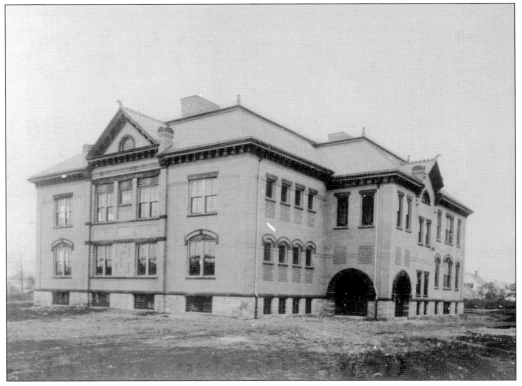

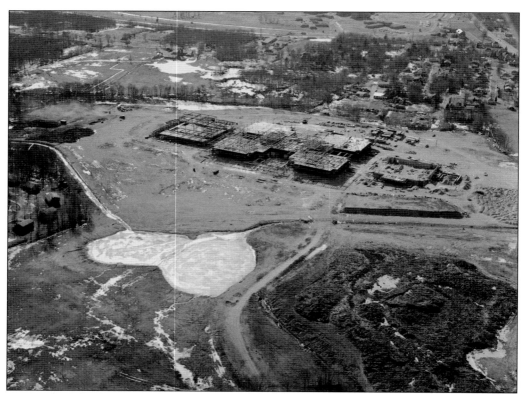

Brockton High School was established in 1871, and the first building had a capacity of 125 students. In 1906, the brick structure on Warren Avenue was constructed and eventually consisted of two buildings. By the early 1960s, it was evident that the student population had outgrown the facility. The city council finance committee responded to this by approving $8 million for a new school. Construction began in 1965, and the school opened in 1970. The above image is an aerial view of the school on the site of former Flagg Pond, while the panoramic view below shows the expanse of the building. It is a third of a mile long and has 13.5 acres of floor space. (Both, courtesy of the Stanley A. Bauman Photograph Collection, Stonehill College.)

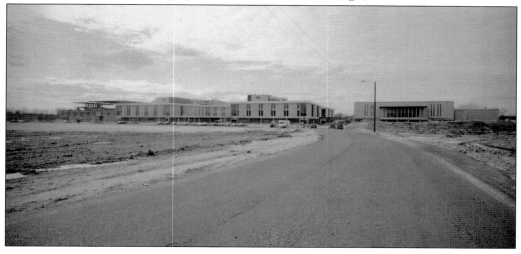

Wesley Lyng Minor (center) was Brockton's premier architect. Designing homes for men with names like Keith, Douglas, Dean, and Kingman and business blocks, such as the Bixby, the Enterprise, and the Times, Minor was also the designer of the gem of the city, city hall. Minor was a native of Louisiana but found Brockton to be the ideal city in which to ply his trade. He is bracketed here by Brockton's first mayor, Ziba Keith (left), and John J. Whipple, the mayor when city hall was dedicated. (Author's collection.)

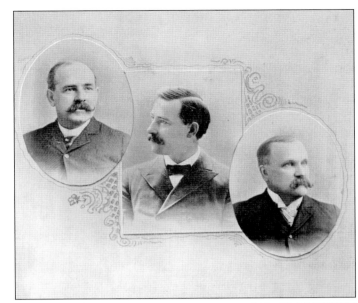

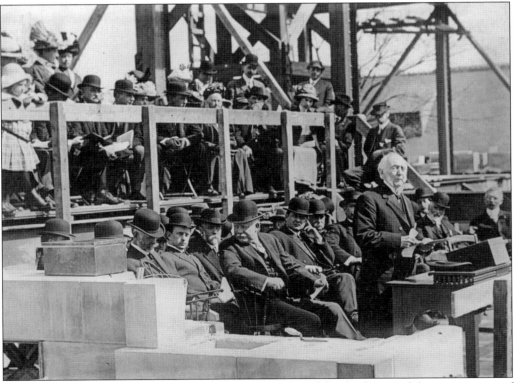

On May 15, 1912, city officials and others of note gathered for the laying of the cornerstone of the Brockton Public Library on Main Street on the site of the old high school. The library was made possible by a gift of $110,000 from steel magnate Andrew Carnegie, whose most remembered philanthropic work was the erecting of library buildings around the country. (Courtesy of the Brockton Public Library.)

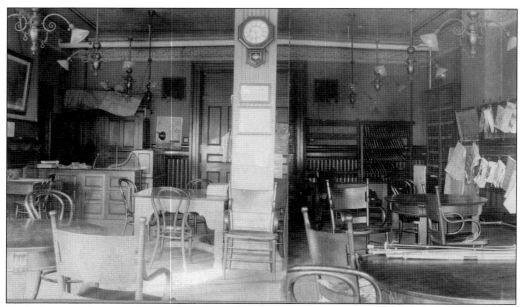

This photograph shows the men's reading room of the library in 1882 when it was located on the third floor of Main Street's Satucket Block. Note the newspapers hanging on the right of the image. The library subscribed to 13 daily and 19 weekly newspapers at this time. Before moving to its present site, the library was also housed in city hall. (Courtesy of the Brockton Public Library.)

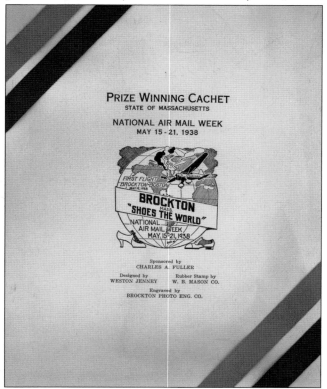

In celebration of National Airmail Week, May 15–21, 1938, contests were held to design cachets for special envelopes originating in various communities. This design by *Brockton Enterprise* cartoonist Weston Jenney was selected as Brockton's winner. With its shoe motif central, it also commemorated the first airmail flight from Brockton to Boston on May 19, 1938. (Author's collection.)

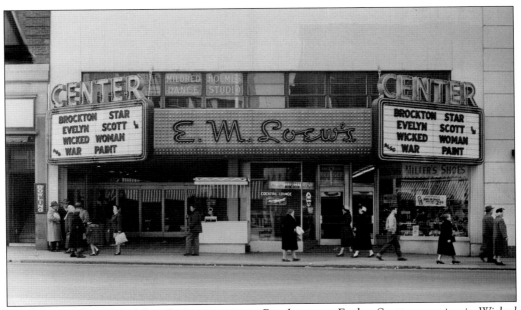

The Center Theatre on Main Street announces Brockton star Evelyn Scott appearing in *Wicked Woman* as Dora Bannister in March 1954. Scott was born in Brockton in 1915 and appeared in several television shows, including *Gunsmoke, Perry Mason, Dragnet, The Untouchables, Bonanza,* and *The Danny Thomas Show.* Her last appearance was in 1985 in *Peyton Place: The Next Generation.* Scott died in 2002. (Courtesy of the Stanley A. Bauman Photograph Collection, Stonehill College.)

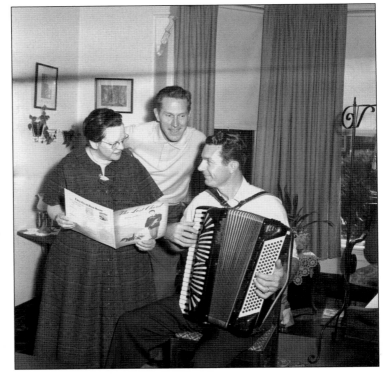

A regular visitor to Brockton stages was internationally acclaimed accordion player and Happy Norwegian Myron Floren (right, with accordion), shown meeting with Brockton friends Doris Tirrell, a music teacher, and businessman Walter Lendh. (Courtesy of the Stanley A. Bauman Photograph Collection, Stonehill College.)

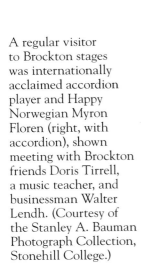

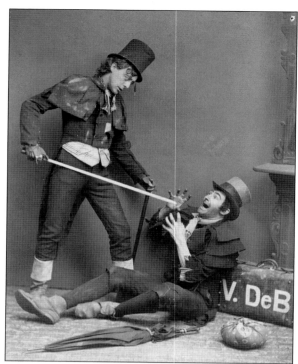

Brocktonians George W.R. Hill (left), the editor of the *Boot and Shoe Recorder*, and Edgar P. Howard, a local merchant, perform as Ravannes and Cadeaux in the musical comedy *Erminie* in 1887. This opera by Bellamy and Paulton was first produced in London in 1885. (Courtesy of the Brockton Public Library.)

The Brockton Historical Society Shoe Museum was largely made possible by the generosity of the Doyle family, and the foundation of its collection is in the William Doyle Sr. Collection. Here, Doyle's sons Albert (left), William (center), and Donald Jr. pose with an extremely large pair of shoes juxtaposed with a small pair. Note the cowboy boot vase on the table. (Courtesy of the Brockton Historical Society.)

Five

CHAMPIONS OF GOD AND COUNTRY

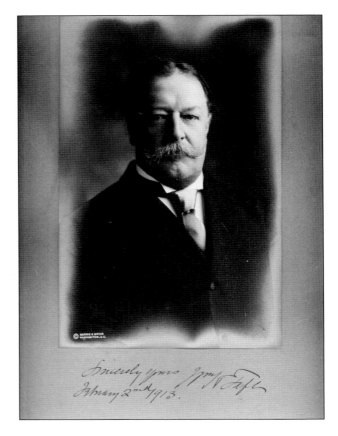

On February 13, 1913, a few months after losing reelection, Pres. William Howard Taft signed this portrait to his friend and loyal supporter Edgar Thompson of Brockton. Taft had visited Brockton and attended the Brockton fair with his wife, Helen, and daughter, also named Helen, on October 3, 1912. Several other US presidents have also visited Brockton on the campaign trail or while in office. (Courtesy of Lloyd F. Thompson.)

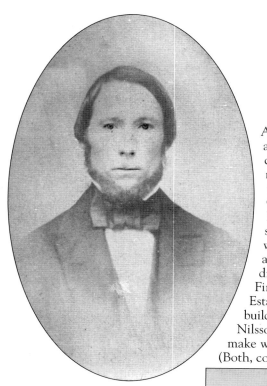

Among the earliest European immigrant groups to arrive in Brockton were the Swedes in 1854. They came to work in the shoe factories and populated mainly the Campello section of the city, although there was strong community in Montello as well. One of the leaders of the Swedish community was Peter Blomstrand, shown at left, a farmer and a shoe worker. A Campello resident, Blomstrand would later move to East Bridgewater and maintain a sizeable farm there. Blomstrand was perhaps the driving force behind the establishment of the First Swedish Lutheran Church, shown below. Established in 1867, the congregation erected this building at the corner of what is now Main and East Nilsson Streets. This building was razed in 1922 to make way for the present edifice of the congregation. (Both, courtesy of First Lutheran Church Archives.)

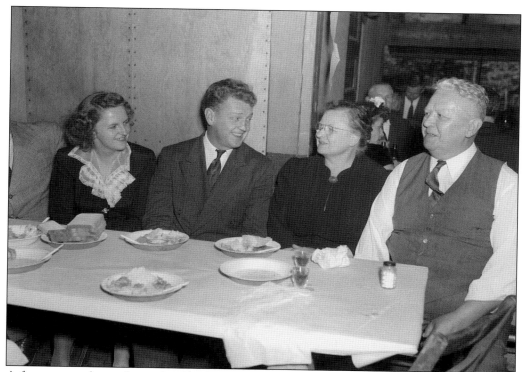

A fortunate welcome home for Charles H. Wychunas, second from left, as he was Brockton's only soldier to participate in the Bataan Death March. Surviving the infamous march of more than 70,000 prisoners of the Japanese in 1942, Wychunas remained a prisoner of the Japanese for the remainder of the war. On the left is Wychunas's sister Clara, who served in England as an army nurse, and his parents, Mr. and Mrs. Casimer Wychunas, are on the right. (Courtesy of the Stanley A. Bauman Photograph Collection, Stonehill College.)

Marching north up Main Street, this World War I–era parade shows the patriotic enthusiasm of the Brocktonians. Many more parades in honor of country and heroes would march along these streets. The low wooden gabled building on the right is where current-day Legion Parkway begins. (Courtesy of the Brockton Historical Society.)

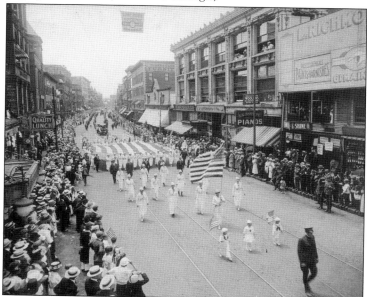

Brockton's Dewey D. Stone was a prominent figure in the Zionist movement of the 1940s and a central figure in the formation of the State of Israel. Along with his brother Harry, a judge, Dewey Stone donated more than 51 percent of the cost of the new laboratory building, pictured above, at Boston University in 1948. As a result, the building was named the Dewey D. and Harry K. Stone Science Building. Below, participants in the dedication ceremonies include, from left to right, Henry C. Berlin, Samuel D. Saxe, Charles A. Rome, Anne A. Stone, Boston University president Daniel L. Marsh, Dewey D. Stone, Morris Stone, David Stone, Reva G. Stone, and Judge Harry K. Stone. (Both, courtesy of the Stanley A. Bauman Photograph Collection, Stonehill College.)

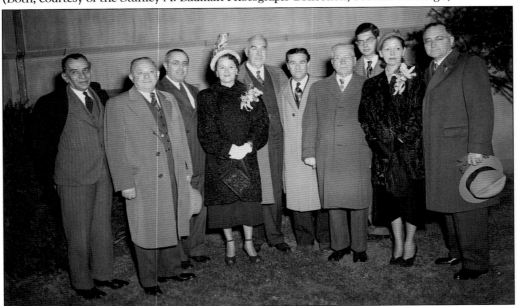

The French immigrants populated the area northeast of the city in the Court Street area and, like all immigrant groups, added to the diversity of a growing city. Among their many social outlets was the Club Nationale on Court Street. This image from September 1931 shows the 100th anniversary float of the Franco-American Society. (Courtesy of the Brockton Public Library.)

The former playground of the Swedish community Scandia Park, located off Plain Street, became home to the Sons of Italy, and on October 11, 1954—the day before Columbus Day—they dedicated their new clubhouse. On hand for the dedication were, from left to right, Theodore Calli; Genesio Casteluzzi, builder; Mayor C. Gerald Lucey; Eugene Cicone; and Gus Garcea. (Courtesy of the Stanley A. Bauman Photograph Collection, Stonehill College.)

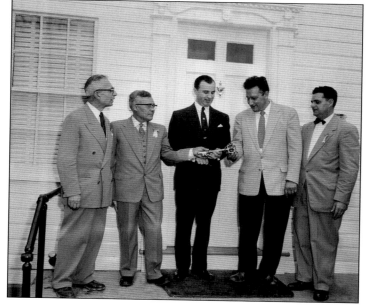

A venerable Campello fixture, Anna E. Johnson (center), the former assistant treasurer of the Campello Cooperative Bank, celebrates her 90th birthday in 1982. Retiring from the bank in 1961, Johnson continued to keep busy by her many volunteer activities. Pictured with her are Gertrude Brooks and Rev. Dr. Michael P. Fruth, the pastor of the First Evangelical Lutheran Church. (Courtesy of the First Lutheran Church Archives.)

The Fern Street Chapel, also known as the Pleasant Hill Chapel, was located on Fern Street near Pleasant Street and was converted into a home by the Quagliozzi family in 1946 during the housing shortage that followed World War II. Working on the house are David Quagliozzi on the left and his brother Edward. Edward served two and a half years in the Army Air Force and received the Distinguished Flying Cross. (Courtesy of the Stanley A. Bauman Photograph Collection, Stonehill College.)

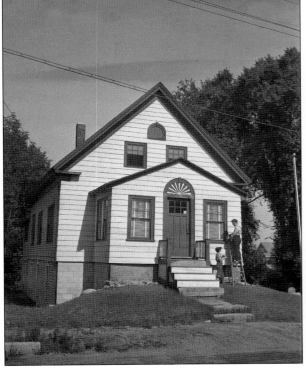

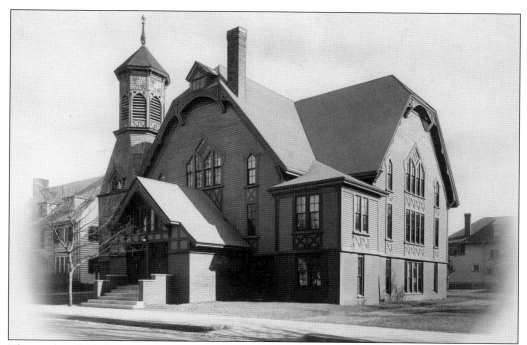

This strikingly different design in church architecture was the South Street Methodist Church in Campello. Today, a parking lot occupies this space; the congregation moved to a new facility on West Chestnut Street in the 1960s. (Courtesy of the Brockton Public Library.)

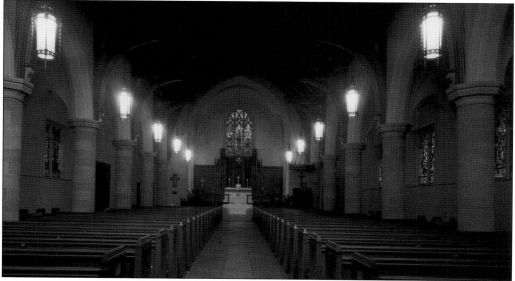

With a storied ecclesiastical presence in the city, the venerable St. Paul's Church, Episcopal, closed in December 2010. Many of Brockton's prominent families called St. Paul's home. In the 1930s, fire damaged the building, which was repaired. Installed following the fire, the stained-glass window over the altar is made from glass taken from windows destroyed in church bombings in England during World War I. (Courtesy of the Stanley A. Bauman Photograph Collection, Stonehill College.)

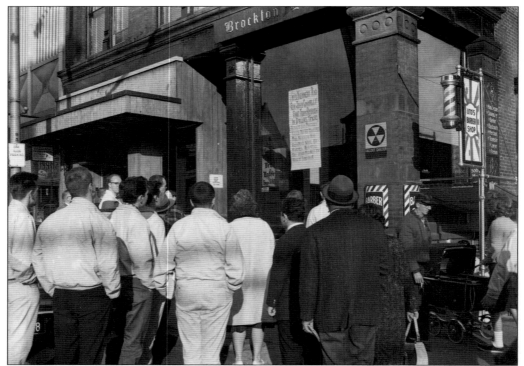

For decades, the Main Street window of the *Brockton Enterprise* was always a source of the latest news bulletins, posted in large print. Here, a crowd gathers to read the news that Pres. John F. Kennedy has been assassinated in Dallas, Texas, on November 22, 1963. (Courtesy of the Stanley A. Bauman Photograph Collection, Stonehill College.)

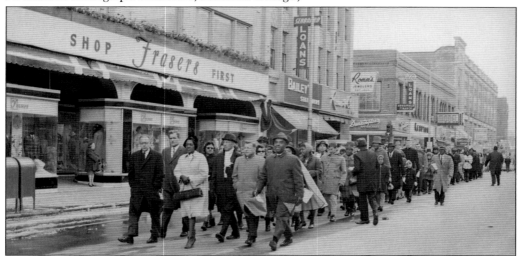

Brockton, like all other urban areas in the country, experienced the civil rights movement in the 1960s. A center of debate in the antislavery question of a century before, Brockton's streets were again the center of activity as the NAACP held a civil rights march on March 21, 1965. The group is seen here walking past Fraser's department store. (Courtesy of the Stanley A. Bauman Photograph Collection, Stonehill College.)

Age and inappropriate materials for a New England climate led to the removal of the columned dome on the tower of St. Margaret's Catholic Church in Campello. On June 1, 1960, a new 3,500-pound cupola was set atop the tower by the Eastern Erection Company of Somerville, Massachusetts. The church was closed in 2003 and is now home to a Haitian congregation. (Courtesy of the Stanley A. Bauman Photograph Collection, Stonehill College.)

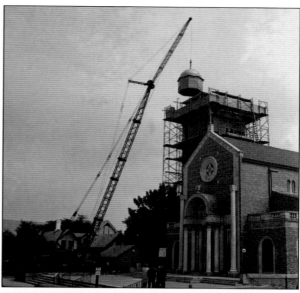

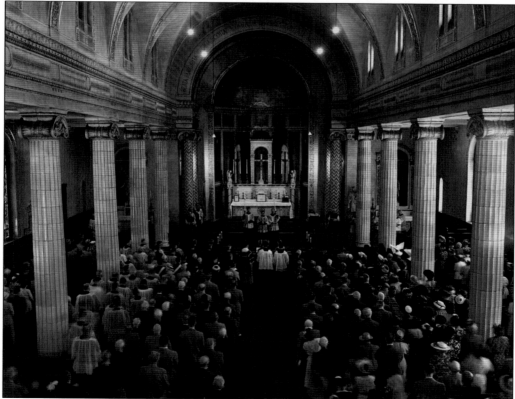

A funeral service for one of St. Margaret's most beloved priests, Fr. Alexander Hamilton, was held in the packed church on August 14, 1948. St. Margaret's was founded in 1902, and a basement church existed on this site until the superstructure and the sanctuary pictured were added in 1924. (Courtesy of the Stanley A. Bauman Photograph Collection, Stonehill College.)

St. Theresa's Maronite Catholic Church at 343 North Main Street was established in Brockton by the Lebanese immigrants who settled in the city. The Maronites are one of the principal ethno-religious groups in Lebanon to this day. The Maronite Church is an Eastern Church but in full communion with the Roman Church. Syriac is the principal liturgical language of the church. (Courtesy of the Stanley A. Bauman Photograph Collection, Stonehill College.)

Graceful arched beams are set in place to form the soaring space of the Olivet Memorial Church on Torrey Street in 1962. This nondenominational church was established on July 9, 1893, by Rev. George Peck of Boston. Basically, four families made up the church at that time, the Littlefields, Haleys, Spauldings, and Tuckers, among a couple others. (Courtesy of the Stanley A. Bauman Photograph Collection, Stonehill College.)

On May 16, 1948, members of the Agudas Achim synagogue honored Rabbi Herman Spiro, left, and his bride, Edith Silverman. Greeting the couple are, from left to right, Florence Dushman; James E. Siskind, treasurer of the synagogue; attorney Albert Shimelovich, president; Fannie Hurwitz; and Minnie Berman. (Courtesy of the Stanley A. Bauman Photograph Collection, Stonehill College.)

Church members and city officials gather in front of the Harold Keith estate at 1383 Main Street to break ground for the new home of Trinity Baptist Church. From left to right are Mayor Hjalmar Peterson, Rev. Clyde Wolf, Edward E. Ekstrom, Henry G. Hanson, Anna Widdell, Frank J. Paulson, Clifford H. Carlson, and Rev. Carl L. Holmberg. (Courtesy of the Stanley A. Bauman Photograph Collection, Stonehill College.)

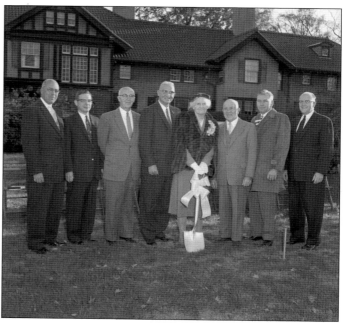

On September 24, 1961, Hope E. Mehaffey became the organist and choir director of First Evangelical Lutheran Church in Campello. A graduate of Boston University and Union Theological Seminary, Mehaffey is seen seated at the console of the church's original 1923 Moller pipe organ, which was replaced in 1968 with a Schantz pipe organ. Mehaffey celebrated her 50th anniversary as First Lutheran's organist in September 2011. (Courtesy of Daryl Haase Dolfe.)

This 1967 photograph portrays the people involved in planning worship at First Evangelical Lutheran Church. From left to right are the following: (first row) Arlene Moberg, Jennie Hollertz, Cheryl Guardino, Pastor Harris L. Willis, Dihie Rudokas, Olga Wells, and Mr. and Mrs. Earl Erickson; (second row) Hope Mehaffey, Edith Anderson, Carole Casey, Walter Wells, Harold Hollertz, Evelyn Hollertz, Gladys Walters, and Claire Haase; (third row) Barbara Anderson, Pearl Ek, Ethel Sylvia, Arthur Hollertz, Thomas MacDonald, Ellen Meada, and Signe Ekholm; (fourth row) Evelyn Johnson, Harold Sigren, Richard Haase, Lester E. Johnson, Wesley Green, and Arthur Walters. (Courtesy of the First Lutheran Church Archives.)

Attorney Robert S. Prince was sworn in as clerk of courts for Plymouth County on February 1, 1960. Administering the oath is associate justice John V. Spaulding (far left) of the Massachusetts Supreme Court, while former clerk of courts George C.P. Olson looks on. Pictured behind Prince are, from left to right, his wife, Geneva, and his parents, attorney Thomas W. and Louise A. Prince. Robert Prince went on to have a long and distinguished career as an attorney and a judge. (Courtesy of the Stanley A. Bauman Photograph Collection, Stonehill College.)

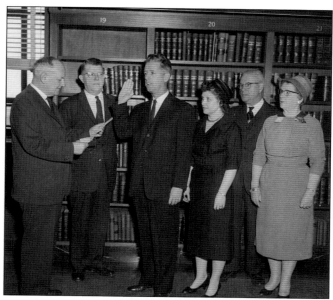

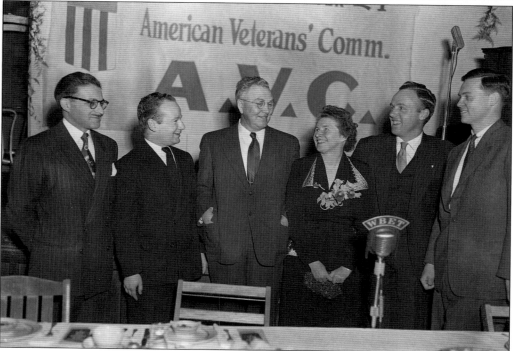

The American Veterans' Committee (AVC) was founded in 1943 as an alternative to the Veterans of Foreign Wars and American Legion. The Brockton chapter named Brockton High's football coach, E. Marion Roberts, its Brocktonian of the Year in 1950. Pictured are, from left to right, George M. Romm, toastmaster; Rev. Lawrence Jaffa, chairman of the chapter; Roberts, Mrs. Roberts, Michael Straight, AVC national chairman; and Endicott Peabody III, AVC state chairman and future governor of Massachusetts. (Courtesy of the Stanley A. Bauman Photograph Collection, Stonehill College.)

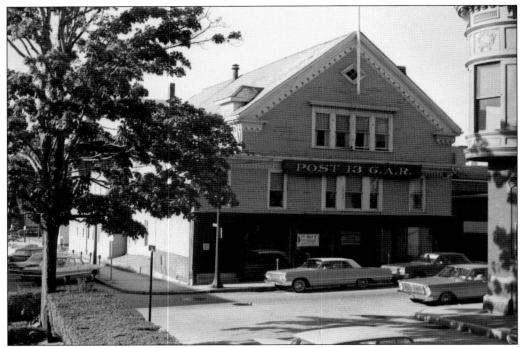

Among the first public advocacy groups in the United States was the Grand Army of the Republic. The GAR was a fraternal group made up of Union veterans from the Civil War. Staunchly Republican in its support, this group ceased to exist upon the death of the last veteran of the war in 1956. The Brockton GAR hall was on School Street opposite city hall and the police station, the corner of which can be seen on the right. This hall was torn down in 1965. (Courtesy of the Stanley A. Bauman Photograph Collection, Stonehill College.)

Charles Sumner Millet, the US consul in China, speaks with his children Lucia, Charles S. III (center), and Nicholas about the steamship *Gripsholm*, which was among the last to leave Shanghai when Americans were being repatriated during World War II. Back in this country, Millet was in charge of returning thousands of Chinese Americans to China. (Courtesy of the Stanley A. Bauman Photograph Collection, Stonehill College.)

Six

CHAMPIONS OF
THE ARENA

The 1950 Brockton High football squad ended the season with a record of 8-2-1 under coach Francis Saba. Members of the team, pictured here at Eldon B. Keith Field, are, from left to right, (first row) Edward Moberg, Vasil George, Robert Lanzetta, Michael Ippolito, Robert Perkins, Wayne Asker, Ray Lessard, and Ralph Chesnauskas; (second row) Sonny Prosper, Sonny Marchegiano, Richard Hancock, Phil O'Connell, Ronald Hermanson, Sonny Lenoci, Jack Hamelberg, and Frank DiBari. (Courtesy of the Stanley A. Bauman Photograph Collection, Stonehill College.)

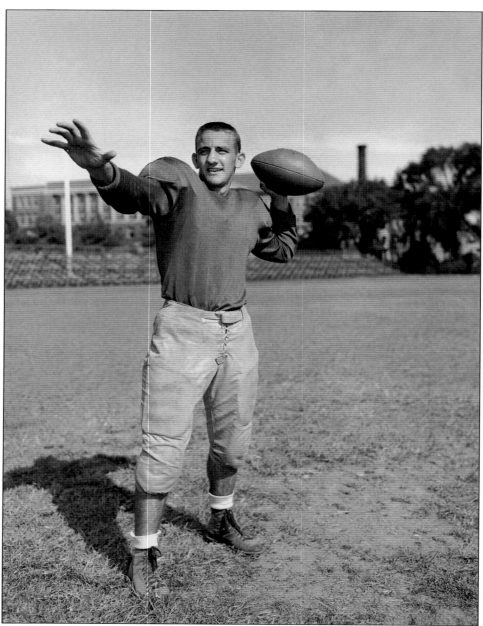

The most successful football coach in Massachusetts's history, Armond Columbo, began his career as a star football player at Brockton High. This photograph was taken of Columbo in 1948, his junior year. Columbo graduated from Stonehill College in 1955 and began coaching at Archbishop Williams in Braintree, Massachusetts, soon thereafter. Columbo took charge of the Brockton Boxers in 1969 and, after a first year season of 3-6, went on to a 9-0 season his second year. He coached nine undefeated teams at Brockton and seven at Archbishop Williams. Columbo, who coached the Boxers through 2002, had the distinction of coaching his five sons on the team. He was also the brother-in-law of boxing legend Rocky Marciano. (Courtesy of the Stanley A. Bauman Photograph Collection, Stonehill College.)

This group of late-19th-to-early-20th-century bowlers represents a number of prominent Brockton names. Pictured are, from left to right, (seated) Dr. George Thatcher, Dr. Ernest Perkins, Charles C. Crooker, Benjamin Caldwell, Herman Tower, Horace Richmond, and Bernard Saxton; (standing) a man identified as Swift, Frank Crocker, and Charles Kingman. (Courtesy of the Brockton Historical Society.)

Bowling was a popular pastime and league sport in the 1950s. Brockton boasted eight commercial bowling establishments and many more in private clubs. The top city bowlers of the 1950 *Enterprise* Tournament were, from left to right, (first row) Edwin Pearson, Lutheran Brotherhood; Jerry Land, YMHA; Eldon Peterson, Interclub; Anthony Coerce, City Ten Pin; Fred Gurney, Commercial Club; William Roberts, Walk Over & Interclub; and Norman Fenn, Young Men's Hebrew Association (YMCA) Juniors; (second row) Herbert Peterson, Vega Club; Oscar Peterson, Memorial Club; Dr. Lyle Reid, YMCA; Carl Hagg, Crescent Ten Pin; Alton Johngren, Men Teachers; Robert Jeppson, Crescent Novice; and James Fruzzetti, Knights of Columbus. (Courtesy of the Stanley A. Bauman Photograph Collection, Stonehill College.)

Brockton High basketball records begin in 1907 when student managers coached the team. In 1914, Arthur Staff became the team's first official coach and amassed a record of 396-160, including the undefeated 21-0 season of 1929, over the next 37 seasons. Staff is pictured here on the left with, from left to right, 1949 cocaptain John Zoino, letterman David Carroll, and cocaptain Robert Joy. (Courtesy of the Stanley A. Bauman Photograph Collection, Stonehill College.)

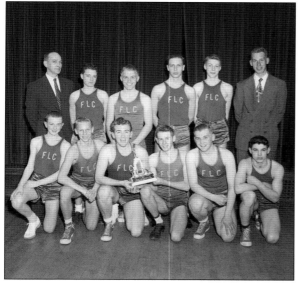

In the 1950s and 1960s, nearly every church in the city had a team that was involved in interchurch basketball. Many of the games were held in the gym of the South Congregational Church. In 1954, First Lutheran Church was the championship team. The champions are, from left to right, (first row) David Erving, Edmund Jeppson, David Sullivan, Fred Bond, Dexter Lawson, and Richard Grabau; (second row) coach Ernest Johnson, Ralph Ferrigno, Kenneth R. Jensen, Kenneth Johnson, Douglas Burgeson, and Robert Johnson. (Courtesy of the Stanley A. Bauman Photograph Collection, Stonehill College.)

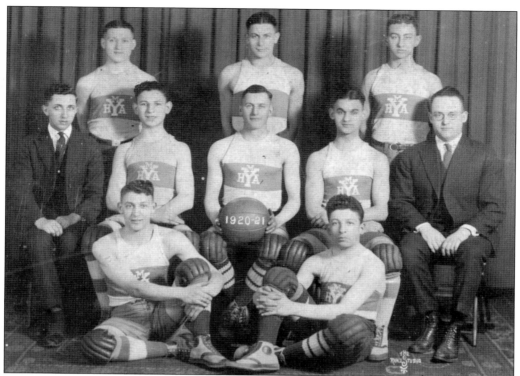

The Brockton Young Men's Hebrew Association was among the earliest city groups to participate in basketball and assembled many good teams over the years. This image depicts the 1920–1921 YMHA team. Those pictured are, from left to right, (first row) Morris Rosen and Lewis Glaser; (second row) manager James E. Siskind, Emmanuel Glaser, Henry Miller, D. Hull, and coach Abram J. Freedman; (third row) Leo Small, Nathan Miller, and Samuel Rautenberg. (Courtesy of the Brockton Historical Society.)

The 1961 YMHA included among its members Kenneth R. Feinberg, who became a successful attorney and gained international fame as the special master of the 9/11 Victim Compensation Fund. Team members are, from left to right, (first row) Scott J. Kriger, Chris T. Kupperman, Charles S. Sidman, Feinberg, Richard Koretz, Russell L. Leavitt, and Brian M. Shacter; (second row) coach Hal M. Pinstein, Lee Kupperman, Paul J Katz, Gerry M. Yaffe, Andrew D. Gale, Michael J. Hirsch, Barry R. Koretz, and Mark Fishman. (Courtesy of the Stanley A. Bauman Photograph Collection, Stonehill College.)

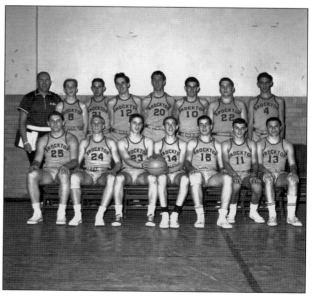

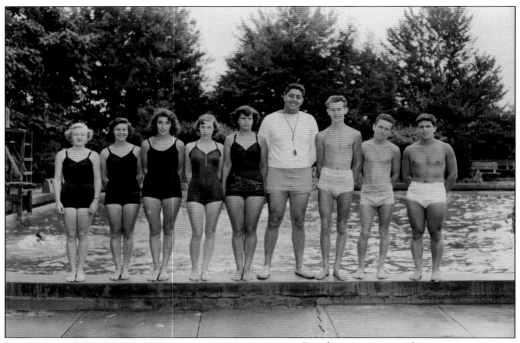

Brockton's municipal swimming pools, several of them gifts from city native and Texas oil tycoon Edgar Davis, were a beehive of activity in the summer. In this 1948 photograph, the Campello pool's lifeguards are ready for the citywide water carnival. From left to right are Marilyn Davies, Cathlene Willis, Alma Perkins, Claire Cahill, Elena Svagzdys, head lifeguard Joseph Harb, John Horton, Kenneth McMullen, and Alfred Alexander. (Courtesy of the Stanley A. Bauman Photograph Collection, Stonehill College.)

With several pools available, many city kids grew up learning both swimming and lifesaving skills through the programs offered. Thirteen-year-old Campello resident Richard S. Spillane (right) saved a young girl at a local beach in 1963 and was made an honorary lifeguard by Campello pool manager Bernard Gilmetti. (Courtesy of the Stanley A. Bauman Photograph Collection, Stonehill College.)

Strange as it may seem today, in 1954, Brockton not only had a sportsman's club for those interested in hunting and fishing, but the members also raised pheasants. Here, from left to right, members George Bollings, Carl V. Nelson, Herbert W. Ness, Louis Blumberg, Clifton D. Hall, George I. Reynolds, and Leo E. Halle prepare to release 101 birds into the wild. (Courtesy of the Stanley A. Bauman Photograph Collection, Stonehill College.)

Among the many sports enjoyed by Brocktonians of all ages was fishing. Ponds at D.W. Field Park and elsewhere around the city provided the venue for such enjoyment. In 1957, Bigney's Pond on Torrey Street was one such place for Richard Albanese (left) and future Brockton fire chief Kenneth Galligan to try their luck. (Courtesy of the Stanley A. Bauman Photograph Collection, Stonehill College.)

On September 10, 1963, world champion pocket billiards player Willie Mosconi delighted patrons at the Brockton Billiard Parlor on Main Street with his display of talent. By the time of his Brockton visit, Mosconi was a world champion having won the World Staright Pool Championship 15 times between 1941 and 1957. In 1954, Mosconi set a world record by running 526 consecutive balls without a miss. (Courtesy of the Stanley A. Bauman Photograph Collection, Stonehill College.)

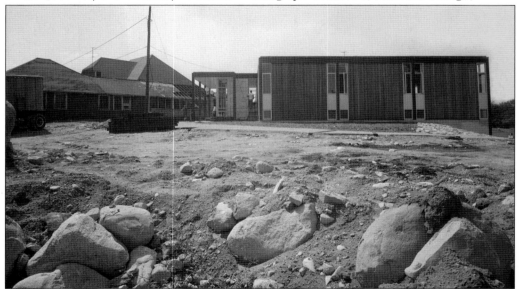

Thorny Lea Golf Club was begun in 1900 by friends within the shoe industry on Alfred Morse's cow pasture on the city's west side. Today, it is one of the region's premier courses. In this 1964 photograph, the clubhouse, built during World War I, is visible in the background as a new glass-and-concrete structure goes up. In 2000, this clubhouse was replaced. (Courtesy of the Stanley A. Bauman Photograph Collection, Stonehill College.)

Seven

CHAMPION OF CHAMPIONS

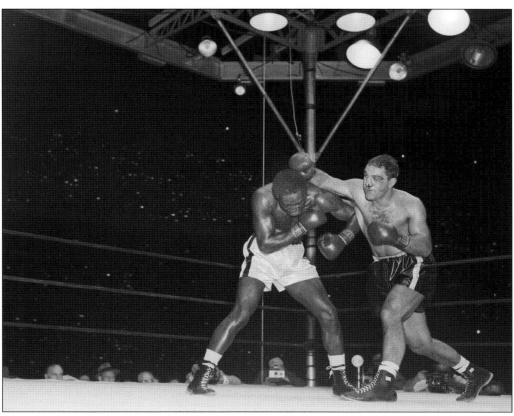

Ring magazine called this September 17, 1954, match-up between Ezzard Charles and Rocky Marciano the fight of the year. With his eye injured and a bad cut on his nose, Rocky continues to hammer at his opponent with a hard right to the head. Rocky won this bout in the eighth and final round of the fight. (Courtesy of the Stanley A. Bauman Photograph Collection, Stonehill College.)

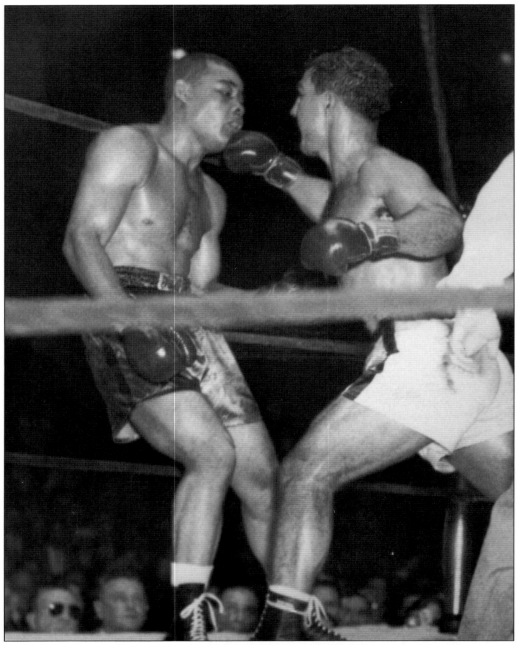

At Madison Square Garden on fight night, Friday, October 26, 1951, Rocky Marciano, age 27, and Joe Louis, 10 years his senior, meet in the ring. It was not to be a good night for the Brown Bomber, who was favored to win. Brockton photographer Stanley Bauman, who was ever at ringside, snapped this action shot of Rocky's famous right hitting Louis square in the jaw; the hit put Louis out. This fight was Louis's last career bout. (Courtesy of the Stanley A. Bauman Photograph Collection, Stonehill College.)

On April 27, 1956, Rocky announced that he was going to retire. On his return to Brockton, the citizens turned out to welcome home and wish well their hometown hero. This image shows Rocky on a ride down Main Street, an event he had come to know after each victorious homecoming. This retirement parade took place on May 3, 1956. (Courtesy of the Stanley A. Bauman Photograph Collection, Stonehill College.)

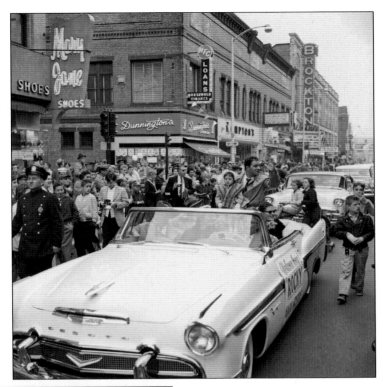

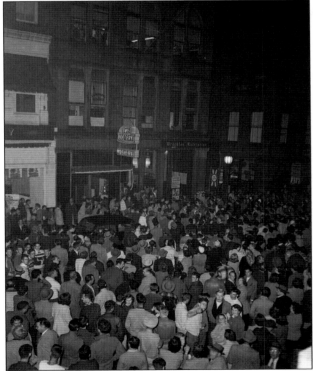

A large nighttime crowd gathers outside the windows of the Enterprise Building waiting for the news to appear regarding Rocky's bout with Jersey Joe Walcott on September 23, 1952. After being dropped in the first round, Rocky came back to battle into the 13th where he dropped Walcott and became the new world heavyweight champion. Rocky faced Walcott a year later and knocked him out in the first round. (Courtesy of the Stanley A. Bauman Photograph Collection, Stonehill College.)

Rocky grew up playing baseball with the neighborhood kids at the James Edgar Playground in his neighborhood and, for a time, was on the Brockton High baseball team. In this 1953 shot, he is shown giving some pointers to his younger brother Lou. In 1947, Rocky tried out for the Chicago Cubs as a catcher but failed to make the team. (Courtesy of the Stanley A. Bauman Photograph Collection, Stonehill College.)

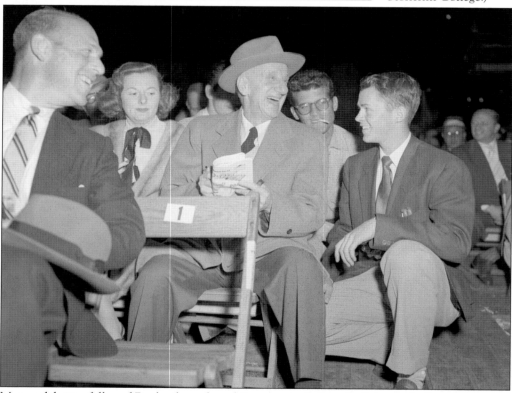

Many celebrities followed Rocky throughout his career, including the Schnozzola, Jimmy Durante. In this undated photograph, Charles "Chic" Fuller, son of *Enterprise* publisher Charles A. Fuller, seized the opportunity to meet Durante at a Rocky fight and obtain his autograph. Note how well-dressed the audience is to watch the fight. (Courtesy of the Stanley A. Bauman Photograph Collection, Stonehill College.)

Pres. Dwight D. Eisenhower smiles as he grabs Rocky's fist and takes a good look at it. From 1943 to 1946, Marciano served in the Army and was stationed part of the time in Wales and assigned to shipping supplies across the English Channel; no doubt Rocky and the president had some stories to share. (Courtesy of the Stanley A. Bauman Photograph Collection, Stonehill College.)

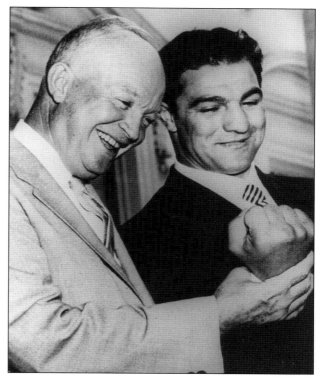

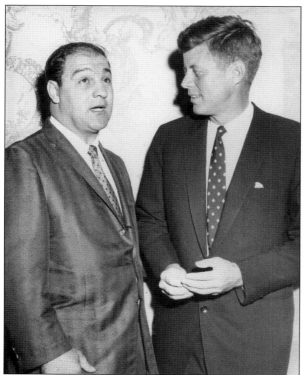

Pictured here with a young Sen. John F. Kennedy, Rocky was continuously in a circle of celebrity, from local politicians to those on the national scene. Also, scores of Hollywood types would follow Marciano and others around on the boxing circuit, much like the way celebrities in all fields of endeavors continue to do today. (Courtesy of the Stanley A. Bauman Photograph Collection, Stonehill College.)

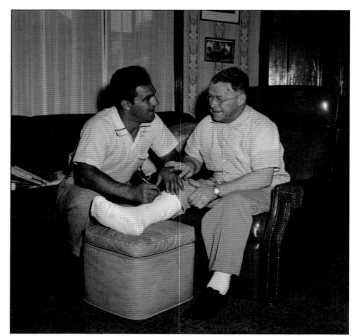

Two days before Marciano's fight against Walcott in June 1953, one of Rocky's greatest fans and supporters, Rev. LeRoy V. Cooney of St. Coleman's Church, suffered an injury due to the fight yet to be fought. Father Cooney (right) fell in the parish hall while overseeing the installation of a television set being put up to broadcast the fight. (Courtesy of the Stanley A. Bauman Photograph Collection, Stonehill College.)

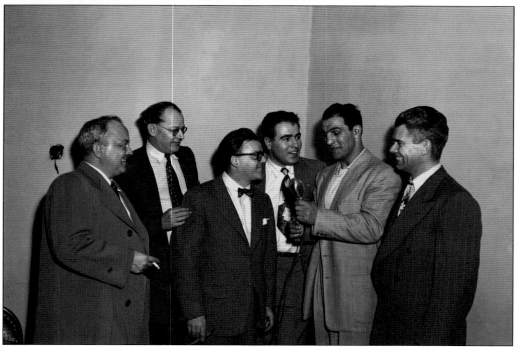

Rocky had a hometown team of photographers and reporters that kept up with his every move. With Rocky in 1952 are, from left to right, Victor DuBois, *Brockton Enterprise and Times* sports editor; Charles A. Fuller, manager of radio station WBET; Kenneth G. Dalton, WBET commentator; Stanley A. Bauman, *Brockton Enterprise and Times* photographer; Rocky; and Walter Dunbar, WBET sportscaster. (Courtesy of the Stanley A. Bauman Photograph Collection, Stonehill College.)

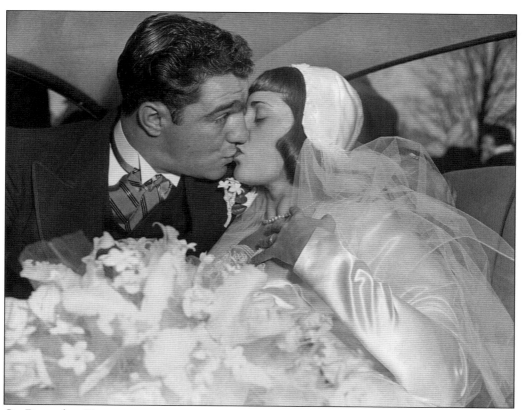

On December 31, 1950, after receiving the permission of his manager Al Weill, Rocky married Barbara Cousins (above), the daughter of a Brockton police sergeant. At right, Rocky stands between his sister Elizabeth Marchegiano and her new husband, Armond C. Columbo, on August 7, 1955. The wedding was held in Brockton's St. Patrick's Church, and Rocky served as an usher. (Both, courtesy of the Stanley A. Bauman Photograph Collection, Stonehill College.)

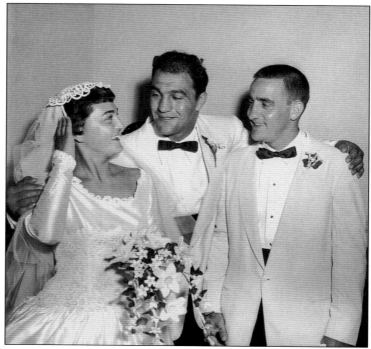

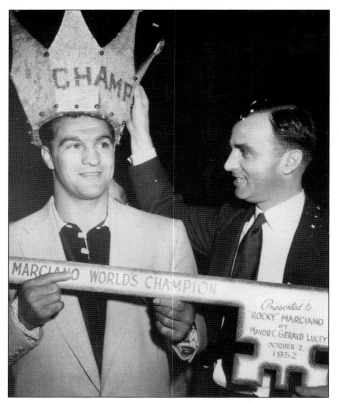

On his return home to Brockton in October 1952 after becoming the world champion, Mayor C. Gerald Lucey presented Rocky with a championship crown and an oversized key to the city. In an age where people were becoming enamored by sports and celebrity, Rocky put Brockton on the map in a new way—hometown pride that had been on the shoe label was now in the sports arena. (Courtesy of the Stanley A. Bauman Photograph Collection, Stonehill College.)

On the day of his retirement, Rocky is pictured here in the center with fire chief Lawrence Lynch (left) and police chief Joseph Wright. The two chiefs had spent much time and energy during the fighter's career dealing with the logistics of safely managing a crowd of thousands of excited fans. (Courtesy of the Stanley A. Bauman Photograph Collection, Stonehill College.)

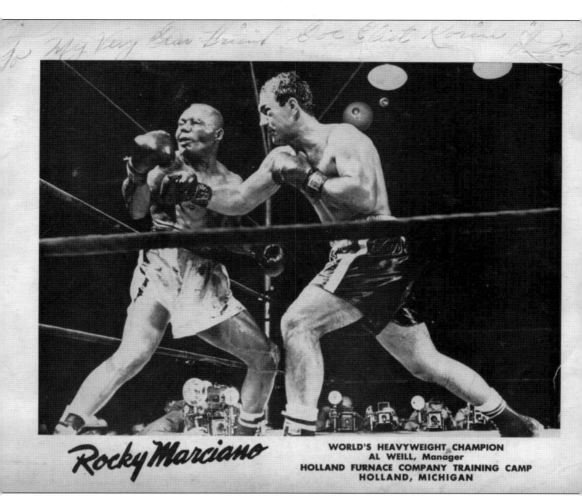

Rocky Marciano

WORLD'S HEAVYWEIGHT CHAMPION
AL WEILL, Manager
HOLLAND FURNACE COMPANY TRAINING CAMP
HOLLAND, MICHIGAN

Rocky inscribed the following on this action shot: "To my very dear friend Doc Eliot Korim." Korim was one of Rocky's doctors and had offices at 85 West Elm Street. Korim was a Lithuanian immigrant who arrived in this country unable to speak English and 10 years later graduated from Harvard College. (Courtesy of Amy Korim.)

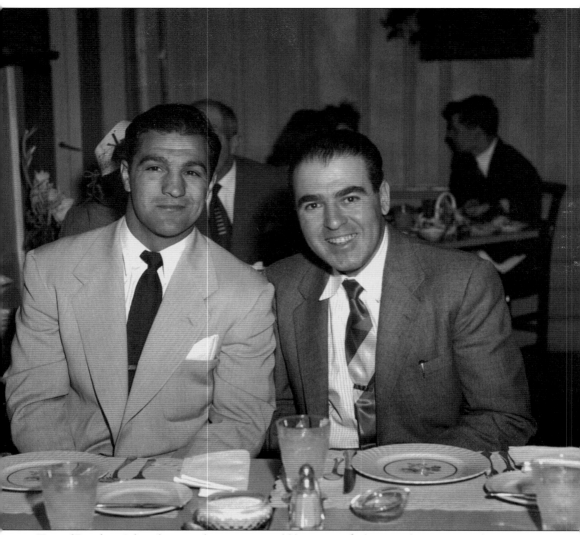

Two of Brockton's best-known champions, world heavyweight boxing champion Rocky Marciano (left) and champion of the lens Stanley A. Bauman enjoy dinner at their favorite restaurant, Whitman's famous Toll House Restaurant. Rocky will be honored in September 2012 with the unveiling of a larger-than-life statue on the grounds of Brockton High School near the stadium bearing his name. Bauman is honored by the legacy he left in his photography being managed and archived by Stonehill College in Easton, Massachusetts. (Courtesy of the Stanley A. Bauman Photograph Collection, Stonehill College.)

ABOUT THE BROCKTON HISTORICAL SOCIETY MUSEUMS

Many of the images in this volume are from the collections of the Brockton Historical Society, and the author is grateful for their use and encourages readers to support and visit the Brockton Historical Society. A portion of the proceeds from the sale of this book will go to support the work of the society.

The Brockton Historical Society is the principal overseer of the complex of museums on Route 27 in Brockton. The main buildings in the regional Heritage Center consist of a fire museum, a shoe museum, and an early Brockton residence called the Homestead.

The Marciano, Edison, and Shoe Museum exhibits are presently located within the Homestead. Since its founding in 1969, the goal of the Brockton Historical Society has been to develop, encourage, and promote a general interest in, and appreciation of, the history of Brockton.

The organization maintains a large collection of significant artifacts and general memorabilia relating to every period of the extraordinary history of the city.

The society is currently involved in a major effort to upgrade the overall facility. This endeavor will greatly increase the opportunities for public tours. To join the Brockton Historical Society, arrange for a special visit, or contribute to the fundraising effort, please contact the society at (508) 583-1039 or visit the BHS website at www.brocktonhistoricalsociety.org.

DISCOVER THOUSANDS OF LOCAL HISTORY BOOKS FEATURING MILLIONS OF VINTAGE IMAGES

Arcadia Publishing, the leading local history publisher in the United States, is committed to making history accessible and meaningful through publishing books that celebrate and preserve the heritage of America's people and places.

Find more books like this at
www.arcadiapublishing.com

Search for your hometown history, your old stomping grounds, and even your favorite sports team.

Consistent with our mission to preserve history on a local level, this book was printed in South Carolina on American-made paper and manufactured entirely in the United States. Products carrying the accredited Forest Stewardship Council (FSC) label are printed on 100 percent FSC-certified paper.

MADE IN THE USA